IMAGES
of America

SAN MATEO
COUNTY COAST

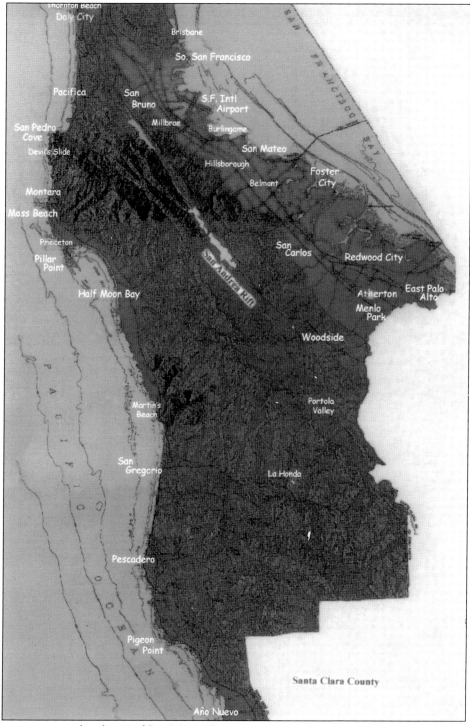

This is a topographical map of San Mateo County.

ON THE COVER: Pictured is J. F. Wiencke, founder of Moss Beach. (Courtesy Spanish Town Historical Society.)

IMAGES
of America

SAN MATEO
COUNTY COAST

Michael Smookler

ARCADIA
PUBLISHING

Copyright © 2005 by Michael Smookler
ISBN 978-0-7385-3061-1

Published by Arcadia Publishing
Charleston, South Carolina

Printed in the United States of America

Library of Congress Catalog Card Number: 2005929653

For all general information contact Arcadia Publishing at:
Telephone 843-853-2070
Fax 843-853-0044
E-mail sales@arcadiapublishing.com
For customer service and orders:
Toll-Free 1-888-313-2665

Visit us on the Internet at www.arcadiapublishing.com

CONTENTS

Acknowledgments 6

Introduction 7

1. Geologic Activity 9

2. Shipwrecks and Lighthouses 33

3. Coastal Access 44

4. Early Coastal Attractions 69

5. Defenses 109

ACKNOWLEDGMENTS

I wish to thank several individuals for their contributions. This book could not have been possible without the input and guidance of Irina Kogan, a geologist for the National Oceanographic Atmospheric Administration (NOAA). Also, some of the more colorful people who shared their memories with me included Ray Martini, Bill Avila, David Havice, Ed Souter, Mary Potter, and Col. Milton Halsey.

Since this is a book about the history of a coast, I wanted a perspective of the area from the sea. Skipper Moon Mullins took me out on his boat so that I could appreciate the coast like early Spanish explorers did as they sailed by.

Ferris Hix and Bob Bueller described their experiences with sea life while diving and fishing on the coast. Commercial fisherman Don Pemberton explained the hardships of making a living on the ocean. Jack Olsen related the "ins and outs" about San Mateo County farming. Former dairy men and current beef cattle ranchers Richard and Jimmie Deeney let me explore their hidden treasure at Martin's Beach. And Yola Picchi, a coast "Lion," related her first-hand experiences with roadhouses of the past.

The archives where I found essential material included the National Park Service Archives, which is located in a remodeled, brick, horse stable at the old Presidio Army Base in San Francisco; the History Guild of Daly City; and the San Mateo County History Museum in the old courthouse in Redwood City.

I would also like to thank the following people who loaned me their photographs: from his collection at the Coastside Museum at the U.S. Bank in Pacifica, Alessandro Baccari; the Spanish Town Historical Association who shared two albums of photographs by R. (Raymond) Guy Smith; Mark Andermahr, owner of the Half Moon Bay Bakery; Georgie Havice Miller; Richard and Jimmie Deeney; Larry Fosnot; Josephine Pecarero Ruschmeyer, Bob Warren, Joe Hillyer, Joseph Lilly, Dennis Inch (station manager for 40 years at the Pillar Point Air Force Station), Norm Schoch, Leevio Marsigli, Frank Bezek, and my dad, 1st Lt. Lawrence Abe Smookler.

INTRODUCTION

Originally incorporated in 1856, the County of San Mateo in 2005 is 449 square miles in size, with a population of over 700,000 people. The county is located on a peninsula between San Francisco and Santa Cruz counties. On its western edge is the Pacific Ocean, and on the east is San Francisco Bay. The western coastline extends about 55 miles from north to south. Most of the habitable area on the coast is pinched between the Pacific Ocean and a coastal mountain range.

Our coast includes many communities, such as Daly City, Pacifica, Montara, and Half Moon Bay. For three of these four communities, Arcadia Publishing has recently printed individual books. They have also recently published a book titled *The Ocean Shore Railroad*. I tried not to duplicate what had already been written or depicted unless it applied to my historical theme.

My emphasis has been what all the communities on the San Mateo County coast have had in common. The context of this story is how the evolving history of the San Mateo County coast has been impacted by the unique geology of the area. This is the common thread that ties the history together.

Throughout its history, the coast has often been geographically isolated by its mountainous terrain, weather frequented by strong winds, and dense fog. These conditions have challenged coast dwellers since the Native Americans first lived here. The challenge has been worth it for most people.

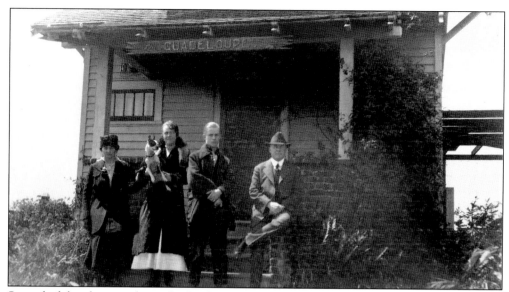

Several of the photographs in this book were taken by R. (Raymond) Guy Smith, who lived in Moss Beach until his death at the age of 82 in 1970. According to Georgie Havice Miller, Guy was a longtime friend and poker buddy of her grandfather, George M. Havice. Georgie said that Guy had the best photography equipment money could buy. He was always taking pictures of something. In the above photograph, taken by someone else, Guy is the man on the right. (Courtesy Larry Fosnot, who bought Guy's house in 1976.)

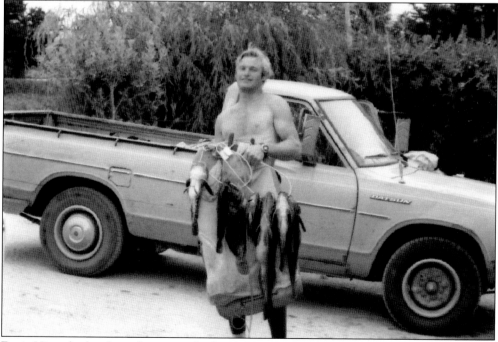

Ferris Hix, who has been diving on the San Mateo coast for over 30 years, said that there are three types of divers: recreational, sport, and hardy. To dive on the San Mateo coast, one should be the latter because of the strong undertow, heavy seas, large waves, and poor visibility. But the rewards can be plentiful, as evidenced by Hix in 1980. (Courtesy Ferris Hix.)

One

GEOLOGIC ACTIVITY

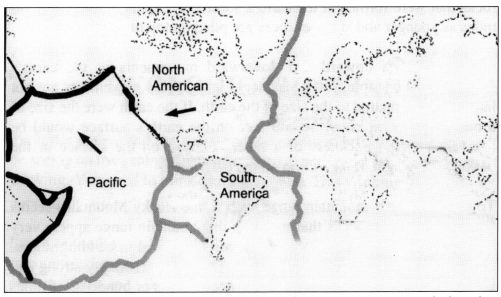

The earth's crust is made up of large and small plates. The San Mateo coast is on the boundary between two large plates—the North American and the Pacific. This boundary extends from the Gulf of California 750 miles northwest to Cape Mendocino. Often where there is a boundary between major plates, there is much geological activity. The arrows on this diagram indicate the direction that the plates are moving. The San Mateo coast sits atop a major geologic plate boundary and, as such, is quite susceptible to earthquakes. According to geologist Irina Kogan, unlike the eastern United States coastline, which is considered calm (because the nearest plate boundary to the eastern coast is in the mid-Atlantic Ocean), the western U.S. coastline is very active geologically and there is a dynamic interaction between the boundaries of the two plates. In fact, the epicenters of the 1906 and 1957 earthquakes were on the San Andreas Fault, close to Mussel Rock in Pacifica.

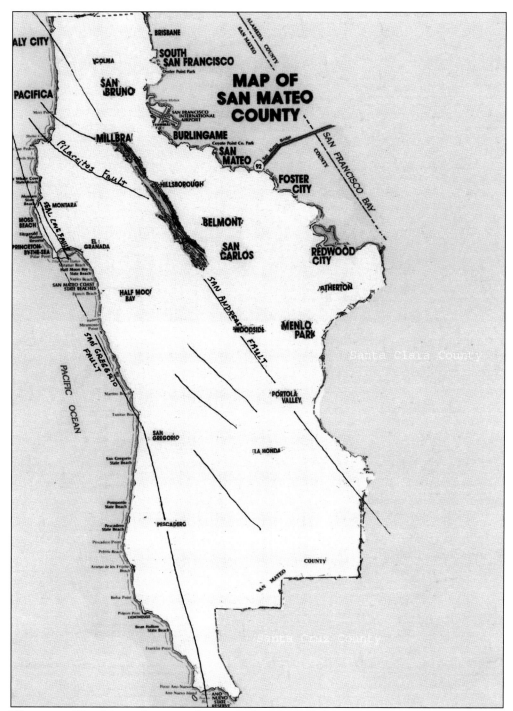

This map of San Mateo County indicates earthquake fault lines running north to south. The location of major faults, such as the San Andreas, the San Gregorio, the Seal Cove, and the Pilarcitos are named on the map. (Courtesy author.)

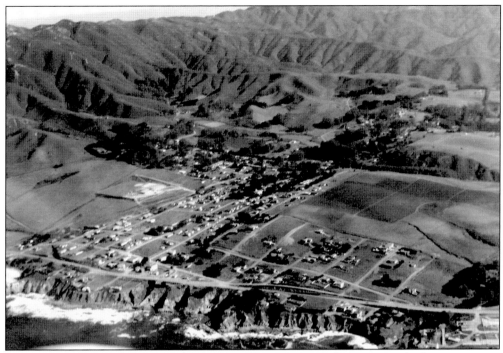

A 1964 aerial view of Montara shows typical landscape on the coast, with the community hemmed in between mountains as tall as two thousand feet and the Pacific Ocean. (Courtesy L. Giacanmo.)

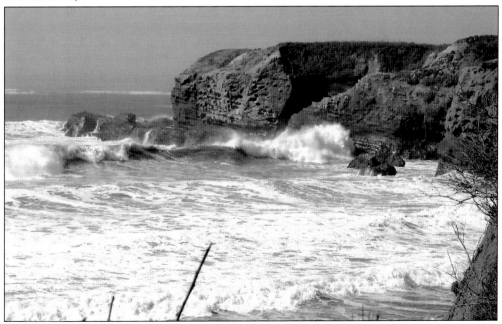

In addition to mountains, this active boundary along the San Mateo County coast has also created steep cliffs and slopes, which end in the Pacific Ocean like these at Año Nuevo. At the base of these landfalls, reefs and jagged rocks meet an ocean of pounding waves. These waves have caused severe erosion and weathering of the coastline. (Courtesy author.)

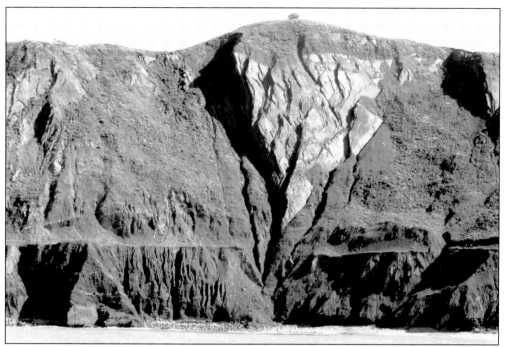

Coastal bluffs and cliffs are dramatically highlighted by landslides caused by a combination of severely weaken rocks, steep slopes, and rainfall. Some landslides are triggered by earthquakes. Here in a V formation is a typical landslide splitting the horizontal ledge on which the railway bed of the Ocean Shore Railroad was built in 1906. (Courtesy author.)

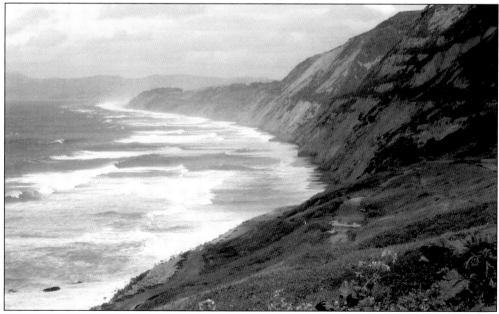

A view of the coastline and the ledge is where the railway bed was built, clinging to the steep sandy bluffs along the coastal cities of Daly City and Pacifica. These landslides have hindered man-made construction projects, such as a ledge carved out for the Ocean Shore Railroad. (Courtesy author.)

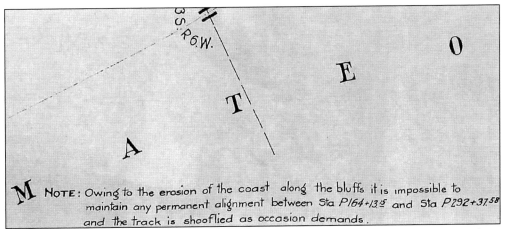

M NOTE: Owing to the erosion of the coast along the bluffs it is impossible to maintain any permanent alignment between Sta P164+13.5 and Sta P292+37.58 and the track is shooflied as occasion demands.

There is an erosion note on the June 30, 1916, right of way and track map of the Ocean Shore Railroad Company for Station 48+00 to Station 255+00. Owners of the railroad understood erosion, but were willing to take a calculated risk building on unstable ground.

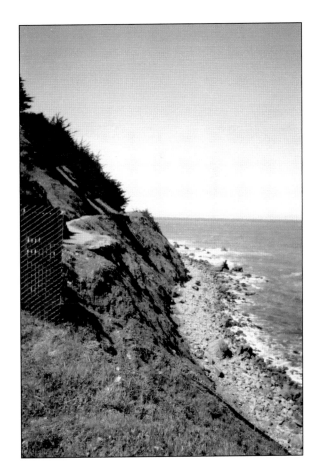

After the railroad tracks were removed, a road was constructed for residents of San Pedro Point cove. However, the road collapsed and residents had to walk the thin ledge about half a mile to their residences.

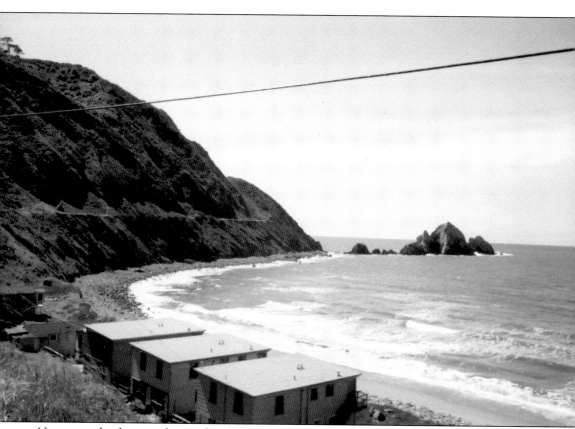

No attempt has been made to widen this ledge around to San Pedro Cove for fear of endangering the houses built above it. (Courtesy author.)

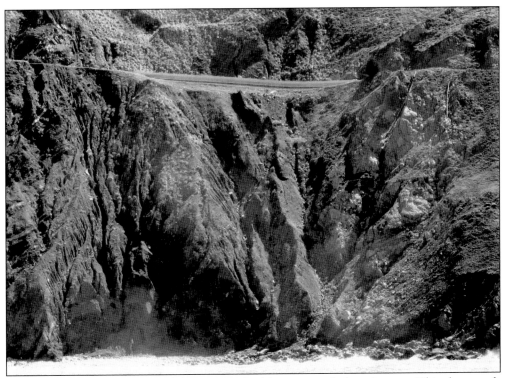

Appropriately known as Devil's Slide, one stretch of the coast road often gives way. This photograph shows how little solid ground supports Devil's Slide. (Courtesy author.)

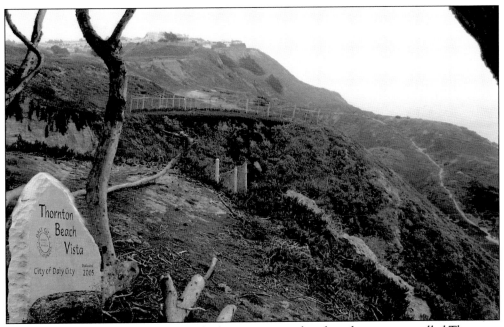

A couple of miles north of Mussel Rock, there was once a beach and picnic area called Thornton Beach. The parking lot, picnic tables, and restrooms are now under three feet of sand from landslides caused by the El Nino storm of 1982–1983. (Courtesy author.)

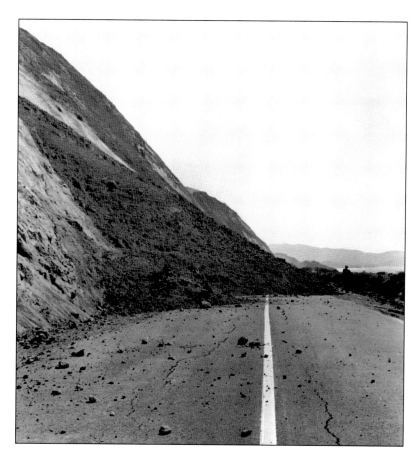

This is the result of a 1951 landslide on Highway 1 near Thornton Beach. (Courtesy A. Baccari.)

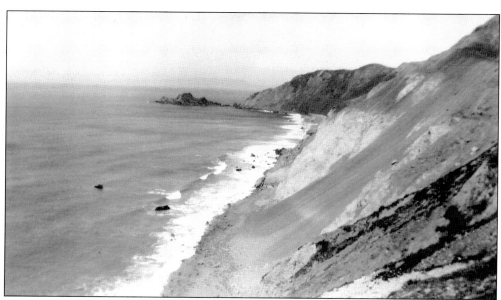

In the 1950s, a landslide closed Devil's Slide near San Pedro Rock. (Courtesy J. P. Ruschmeyer.)

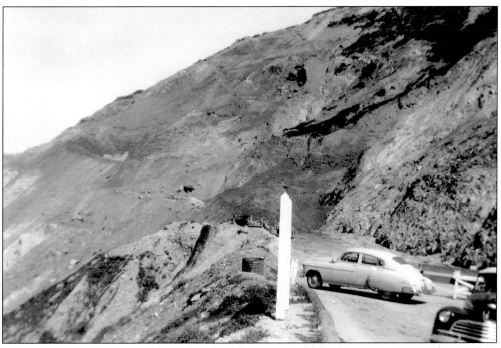

The south end of Devil's Slide was closed by the 1950 landslide. (Courtesy J. P. Ruschmeyer.)

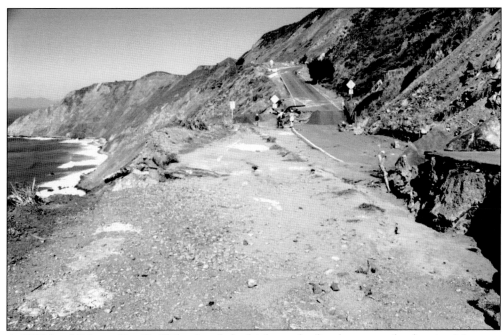

A 1995 landslide on Devil's Slide closed the highway for five long months, leaving Montara residents to live in the largest cul de sac in the state. (Courtesy Stacey Rudio.)

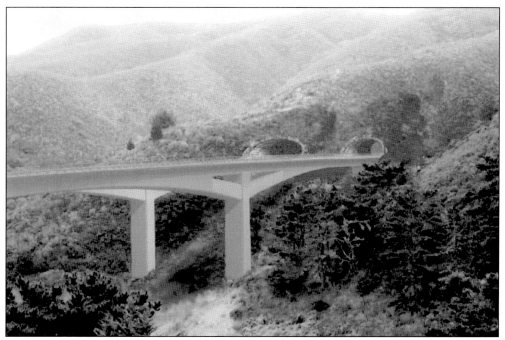

In the early 1970s, a federally funded ($55 million) project planned to move the coast highway inland away from the unstable area. However, there was public opposition to the plan because the new highway might mar the landscape and bring more people.

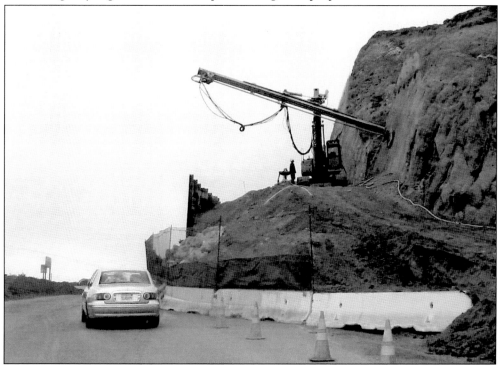

Work began in May 2005 instead on a $270 million, three quarters of a mile long twin bore tunnel and bridge.

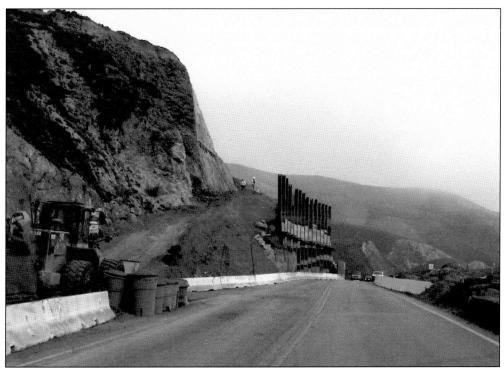

A temporary retaining wall is erected to protect traffic during construction of tunnel. Hopefully these engineers know how to build a safe and structurally sound tunnel better than those who built the railroad and highway before them. (Courtesy author.)

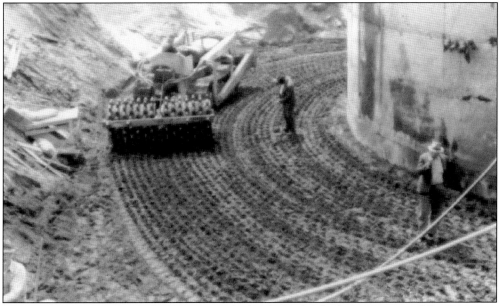

Unstable sandy ground under Fort Funston, which is located in both San Mateo and San Francisco counties, has been a challenge since construction first began in 1917. Here the sand is being compacted around a pre–World War II upgrade. This is the construction of a foundation for one of two 16-inch guns. (Courtesy National Archives.)

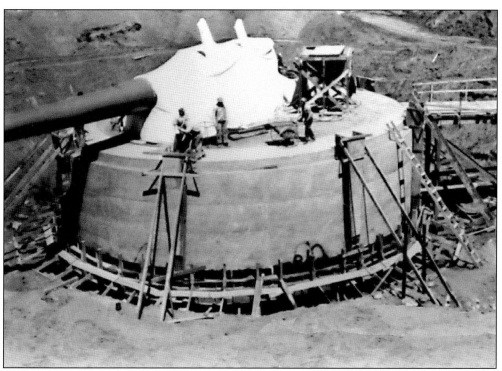

At Fort Funston, this 16-inch gun is mounted on a concrete base. (Courtesy National Archives.)

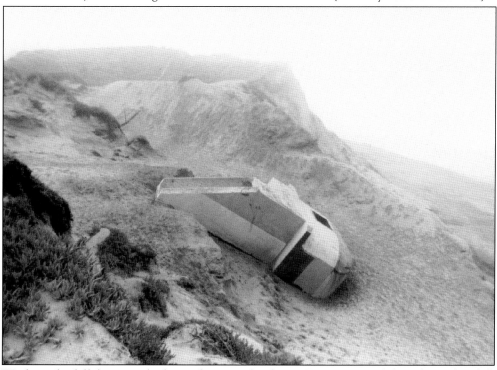

Weak sandy cliffs have resulted in at least one bunker at Fort Funston sliding down the cliff. (Courtesy author.)

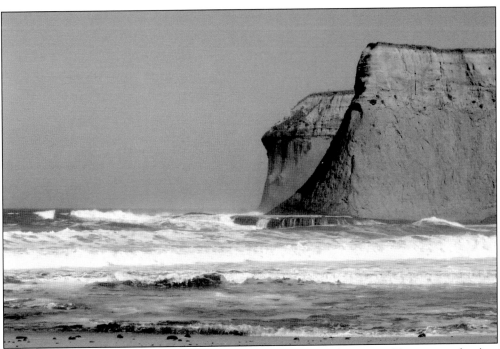

Steep cliffs with pounding waves at their base make for spectacular views. (Courtesy author.)

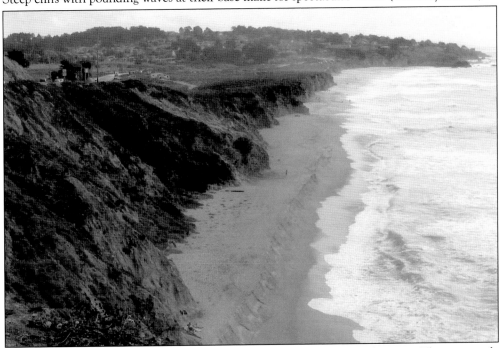

According to Ferris Hix, the sand at Montara beach is the cleanest on the coast. The strong tide and wave action moves the sand from one end of the beach to the other twice each year, which cleans the sand. In the early 1900s, this clean sand was sold to builders. The ocean outlet for Martini Creek is located here where the early Spanish explorer Capt. Gaspar Portola rested his 1769 expedition. (Courtesy author.)

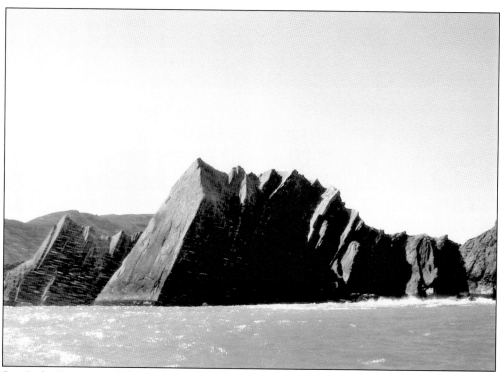

San Pedro Rock, a rock formation in Pacifica, is about 65 million years old. Notice the distinct layers of flat rock on top of each other that appear as if they are thrusting from the sea. This view of this rock can only be seen from the sea and is what early European explorers would have seen from their ships as they sailed by. (Courtesy author.)

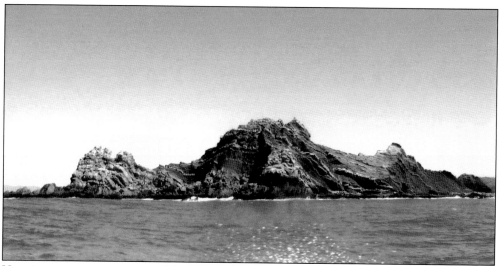

Here is a more common view of the strata of this rock formation, often seen during the days of the Ocean Shore Railway operation. (Courtesy author.)

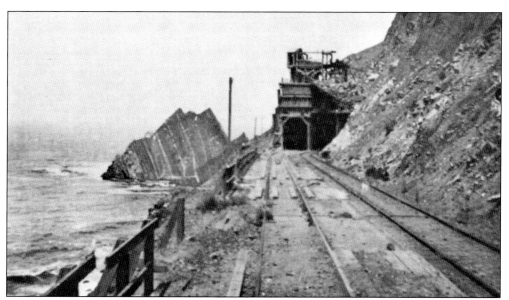

A train traveled through a quarry on the south side of San Pedro Point. (Courtesy A. Baccari)

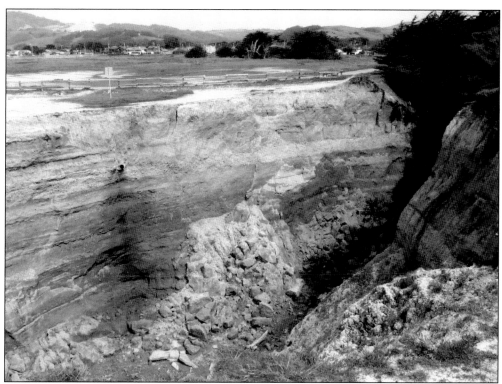

The broad, flat coastal areas around Half Moon Bay are ancient marine terraces or wave-cut benches uplifted to their present position. The rocks beneath the flat surface are one to two million years old and are called the Purisima Formation. (Courtesy author.)

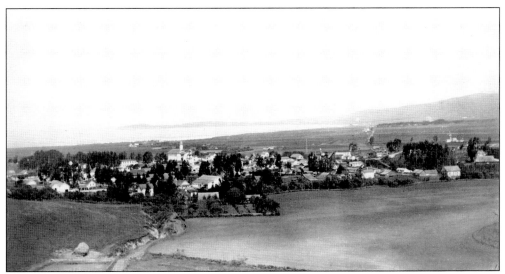

The Purisima Formation, or flat terrace, is easily seen in this 1920 photograph of Half Moon Bay. (Courtesy A. Baccari.)

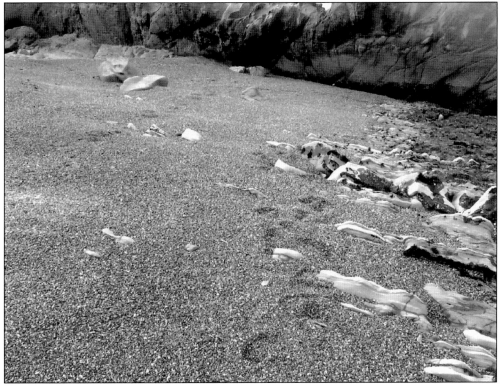

A unique feature on this coast is found at Pebble Beach, a few miles north of the Pigeon Point Lighthouse. (This is not the Pebble Beach in Monterey County.) Pebble Beach is unlike anywhere else on this coast—it is composed of semiprecious pebbles. Geologist Irina Kogan explains that the reason the pebbles on this beach look different than other pebbly beaches on this coast is because this area has strong waves carrying the smaller pieces away, and leaving the larger pebbles behind producing a pebble beach.

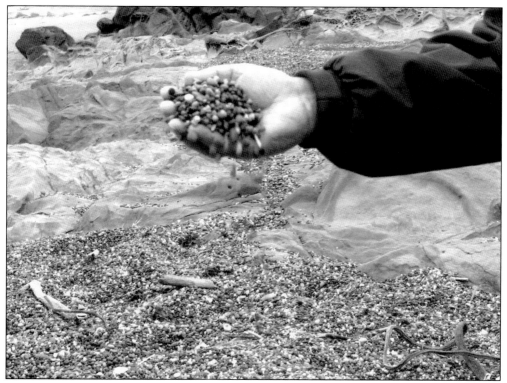

The pebbles at Pebble Beach are small and colorful.

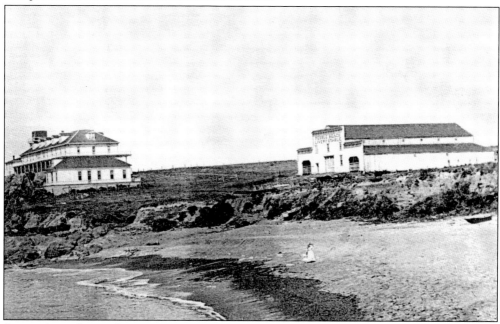

One early settler on the San Mateo coast believed the uniqueness of the pebbles would attract tourists. Loren Coburn built a hotel and a livery stable overlooking the site. But only a few customers ever came to the hotel. The hotel burned, and its ruins and the livery stable were bulldozed for Highway 1. (Courtesy A. Baccari.)

In 2005, Pebble Beach is easily accessible from a parking lot and a short flight of wooden stairs. (Courtesy author.)

Mussel Rock in Daly City is located at the base of a landslide. (Courtesy author.)

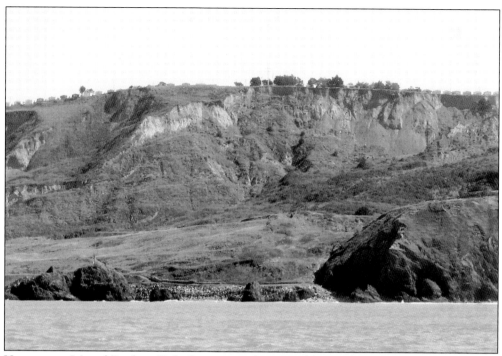

Homes near Mussel Rock in Daly City are in the second largest landslide area in California. Doegler homes built in the 1940s, have been destroyed due to slides caused by weak slopes, heavy rainfall, ocean waves, erosion, and earthquakes.

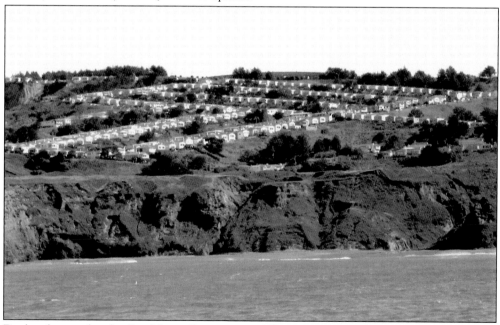

Doelger homes dot the San Mateo County coast. The average rate of erosion in this area over the last 50 years is two to three feet a year. However, recent major El Nino storms in 1982–1983 and 1997–1998, occurring in conjunction with high tides and strong waves, resulted in as much as 20 feet of land sliding in some places. (Courtesy author.)

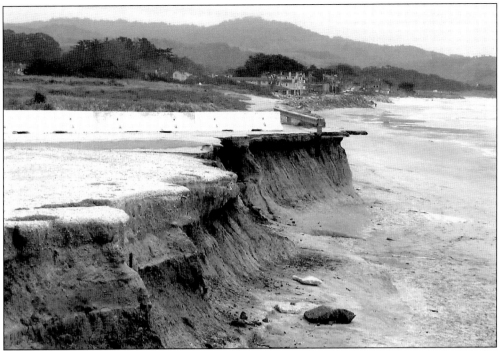

Sometimes erosion has been enhanced my human engineers on the San Mateo coast. In 1958, the Corps of Engineers constructed a breakwater at Princeton-by-the-Sea to create a harbor for a fleet of fishing boats and pleasure craft. Wave action was changed by the breakwater, and parts of California State Highway 1, south of the breakwater, eroded away. The highway was rebuilt inland, though the ocean is encroaching ever closer. Large riprap has been placed to protect the highway. (Courtesy author.)

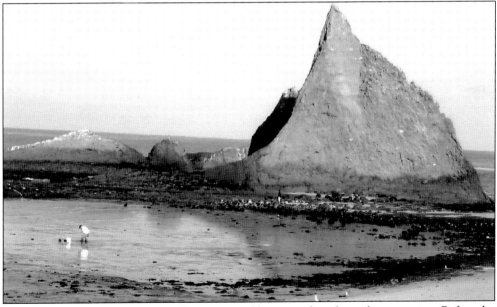

Shark Tooth Rock at Martin's Beach was created by an earthquake and wave action. Before the breakwater was built, Shark Tooth Rock did not exist—it was part of the seaside cliffs.

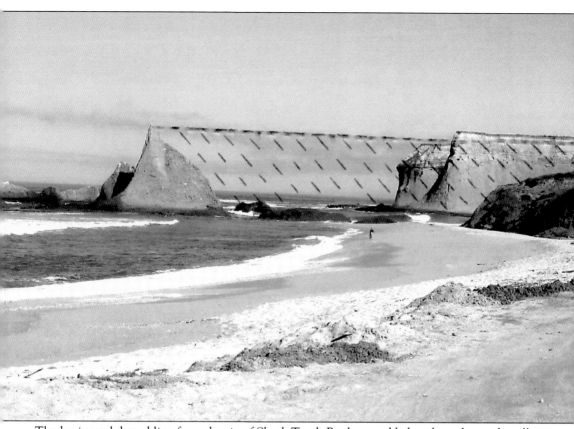

The horizontal dotted line from the tip of Shark Tooth Rock was added to show the earth wall that once connected the Shark Tooth Rock to the cliff at the right. Before the wall fell, one could not walk to Mackay Cove or see the cliffs on the other side without climbing over the wall. The 1906 earthquake cracked the earth wall, and according to Richard Deeney, the owner of Martin's Beach, erosion caused by redirected waves from the breakwater collapsed the wall leaving Shark Tooth Rock.

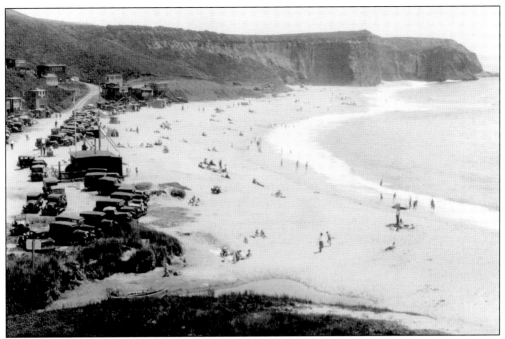

Richard Deeney said that before the breakwater was built, the beach was almost 100 feet further out than it is today, as evidenced by this 1925 photograph. In 1856, ancestors of the Deeney family arrived on the coast. They operated a dairy and cattle ranch on the east side of present-day Highway 1. Over the years, the cost of feed, the expense of hauling cattle over the mountains, and increased government regulations, caused the dairy to close. Today they only raise Angus beef cattle and manage Martin's Beach.

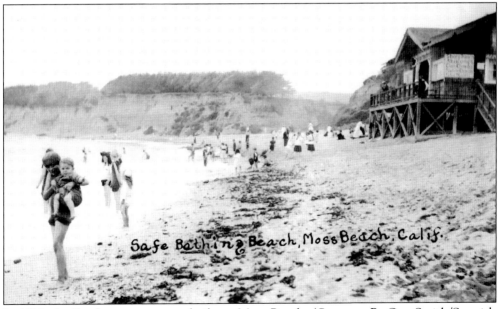

Safe Bathing Beach, Moss Beach, Calif.

In 1914, the Reefs restaurant was built on Moss Beach. (Courtesy R. Guy Smith/Spanish Town Historical.)

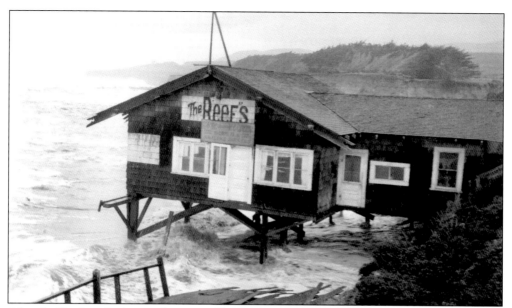

After the Reefs washed away, the owner Charley Nye, built a new Reefs restaurant further inland. A tsunami hit the San Mateo County coast in 1946, and the low marine terrace areas were flooded. (Courtesy R. Guy Smith.)

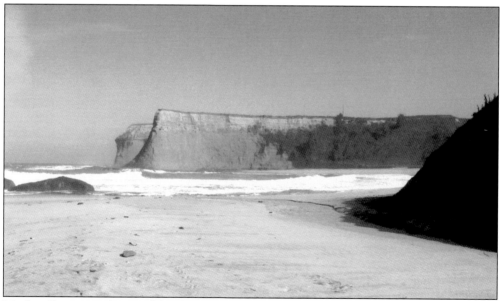

Mackay Cove was often used for the landing of illegal liquor. Ships were also loaded with farm products. Giant rings anchored in the cliffs were used to secure these ships. Remnants of these rings remain on each side of the cove today. The geologically diverse coastline, from its southern tip at Año Nuevo to its northern border with San Francisco County created by earth movements, reveals many different rock types of varying ages in a relatively small area. Despite occasional earthquakes, landslides, and tsunamis, this rugged Pacific Ocean coast with its many natural attractions has held a magnetism for its population since early Native Americans lived here. Isolation has been a reward for its people. People have taken advantage of this isolation and rugged coast to build restaurants, hotels, and homes with spectacular views.

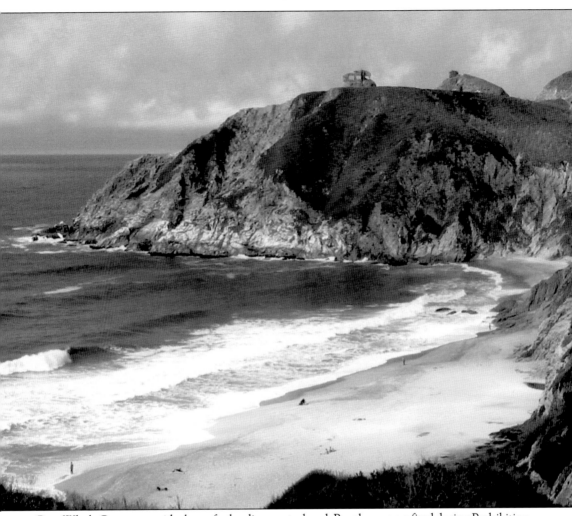

Grey Whale Cove was an ideal spot for landing contraband. Bootleggers profited during Prohibition on the San Mateo County coast because there were hidden coves, caves, and fog to conceal their activities.

Two

SHIPWRECKS AND LIGHTHOUSES

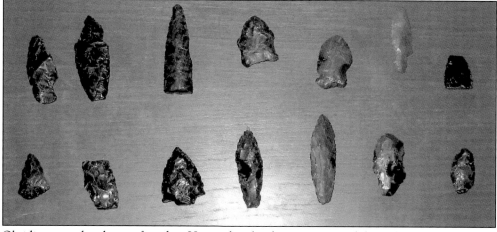

Obsidian arrowheads were found on Havice farmland in Montara and throughout the San Mateo peninsula. Native Americans traded for arrowheads made of obsidian, which is not a native rock of the coast. Nomadic Native Americans populated the rugged coastal terrain of the San Mateo County peninsula for 500 years before Spanish explorers arrived in the 16th century. The coast geography contributed to providing many sources of food—from seeds to gather, wildlife to hunt, and seafood to catch. Though the coastal mountain range isolated native villages, the mountains did not prevent them from trading with tribes in other parts of California. When Spanish explorers arrived on the San Mateo peninsula, they called the Native Americans Los Costanons (meaning the Coast People or Coast Dwellers). The estimated population of the Los Costanons in 1100 A.D. on the San Mateo peninsula was 7,000 to 10,000. Known today as the Ohlone Indians, there are about 200 descendants of these people remaining.

Known as the last Ohlone on the coast, Andres Osorio was 113 years old when he died in Half Moon Bay in 1946. Chris Hunter's book *Pacifica* and Kathleen Manning's book *Half Moon Bay* (both published by Arcadia) thoroughly cover the history of the Native American people of the San Mateo coast. (Courtesy A. Baccari.)

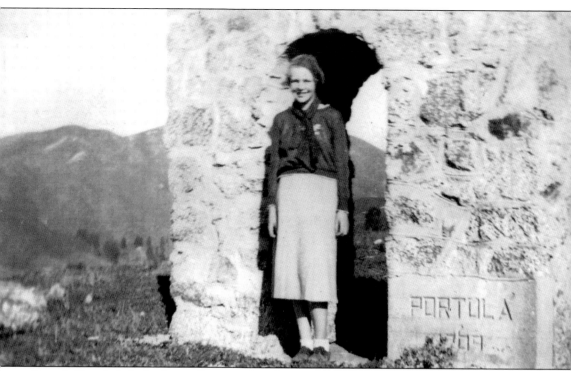

Captain Portola led a land expedition north to locate and explore Monterey Bay. Poor maps and fog caused Portola to miss this bay. Portola's expedition followed the coastline until it reached the mouth of Martini Creek at the base of Montara Mountain. The mountains forced the explorers to veer to the northeast and hike over the coastal range. From the top of the range at what is today called Sweeney Ridge, Portola led the first European land expedition to see San Francisco Bay. A monument was built overlooking Portola's campsite at Martini Creek in 1912 by Harr Wagner, who was an early land speculator in Montara. A longtime resident of Montara, Georgie Havice is seen here standing at the base of the monument in the 1930s. The monument is still standing, but is completely surrounded by a dense grove of trees. (Courtesy G. Havice.)

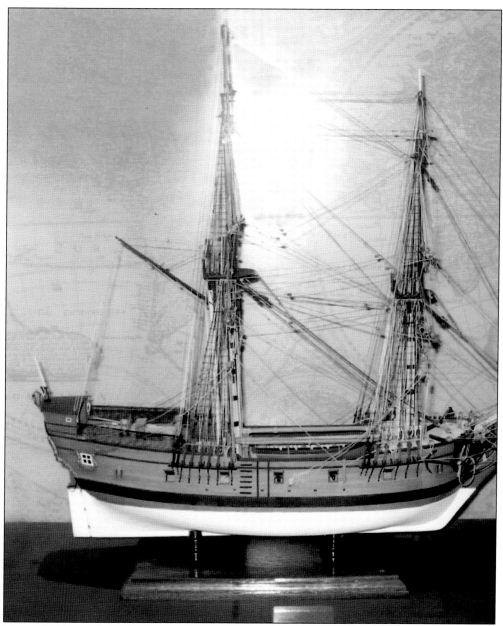

History books credit Don Juan Manuel de Ayala of the Spanish Royal Navy with sailing the first European ship into San Francisco Bay. Ayala's flagship was a small brigantine only 79 feet long. Sailing slowly northward from San Diego against contrary winds from the northeast, the Spanish watched carefully for barely submerged rocks and reefs. They observed whales and other sea life as they made their way up the coast before finally reaching San Francisco Bay. A wooden model of the *San Carlos*, the Spanish flagship of Captain Ayala, was built by Charles Parsons and is on display in the old courthouse in Redwood City, California.

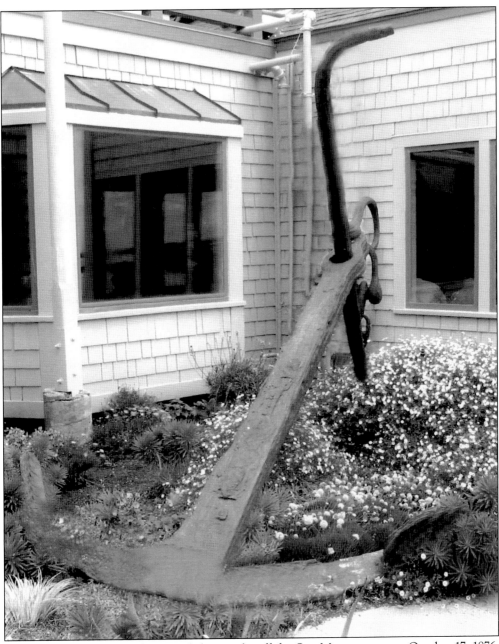

Fog was the main reason for several shipwrecks off the San Mateo coast: on October 17, 1876, the 1,864-ton square-rigged *Rydal Mall* sank a half mile offshore of Pillar Point; on July 14, 1896, the steamer *Columbia*; on August 9, 1913, the lumber schooner *Point Arena*; and on August 29, 1929, the coastal liner *San Juan*. Fourteen feet long and weighing two tons, the anchor of the *Rydal Mall* today sits in front of the Half Moon Bay Brewing Company Restaurant on Capistrano Road at Princeton Harbor. (Courtesy author.)

Fog is a problem throughout the year, as proven by the loss of the 999-ton clipper ship *Sir John Franklin* on January 17, 1865. Twelve men, including her captain, died. The crew was buried at Franklin Point. In 1867, the British bark *Coya*, weighing 515 tons, became lost in the fog near Pigeon Point. It hit a reef, turned over, and sank, taking 27 people down with her. But the worst loss of life along the coast occurred in 1929 when the passenger steamer *San Juan* was rammed, south of Pigeon Point, by the Standard Oil tanker *SCT Dodd*. Seventy-nine people died in this collision. As the losses in ships, cargo, and human life increased, fog signal stations, mostly built in the early 1870s, and lighthouses were built along the coast. In September 1871, a little north of Año Nuevo, a fog signal went into operation at Pigeon Point. The original building contained a steam fog whistle. The steam system burned one cord of wood every 10 hours and it took 45 minutes to get the fire stoked enough to produce steam for the whistle. On an island 900 yards offshore from Año Nuevo, another signal was erected in 1872. In 1875, a steam whistle was also installed at Point Montara. In 1899, the current structure replaced the original one. Near the peak of the roof is a two-ton, diesel-powered system that was used from 1935 to the mid-1960s. A fog signal was also setup at Pillar Point. To this day, fog signals on this island off Año Nuevo still warn ships of the dangerous rocks and reefs nearby. This signal became fully automated in 1948, and the island's only inhabitants today are seals. (Courtesy author.)

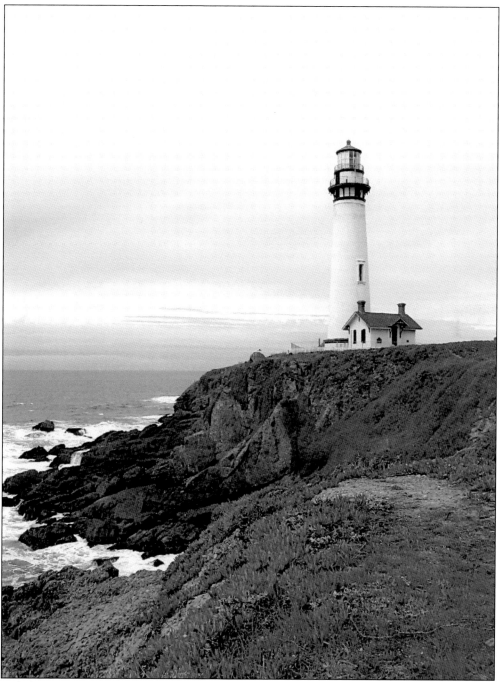

Lighthouses, to augment the fog signals, were built at Pigeon Point and Point Montara. The Pigeon Point Lighthouse was named after the clipper ship *Carrier Pigeon*, which sank in May 1853 off Año Nuevo Point. In 1872, Congress approved funds for a 115-foot tall lighthouse at Pigeon Point. Pigeon Point Lighthouse is the tallest lighthouse on the west coast and one of the tallest in the United States. (Courtesy author.)

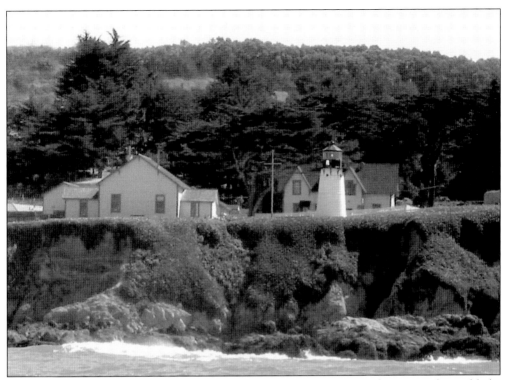

In early 1900, before a lighthouse was erected at Point Montara, a post lantern with a red light was setup to warn ships. By 1928, a 30-foot tall prefabricated cast iron lighthouse was put into operation. In 1963, the station was fully automated. Fog signals and lighthouses did not prevent further loss of ships on the San Mateo coast, though. For example, in 1921, the captain of the USS *Delong* (DE-684), pictured below, a 20th-century-built U.S. "four stacker" destroyer, got lost in the fog and ran aground at Kelly Beach in Half Moon Bay. The ship was impossible to get off the beach without taking it apart, so the two-year old destroyer was scraped. Pictured above as seen from the sea today, the buildings of the Point Montara Lighthouse are utilized as a hostel. (Courtesy author.)

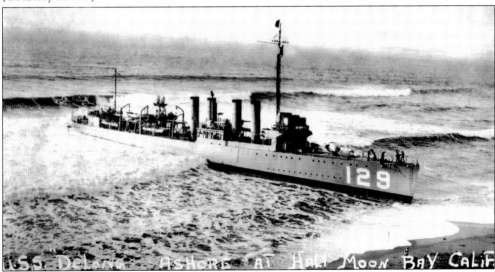

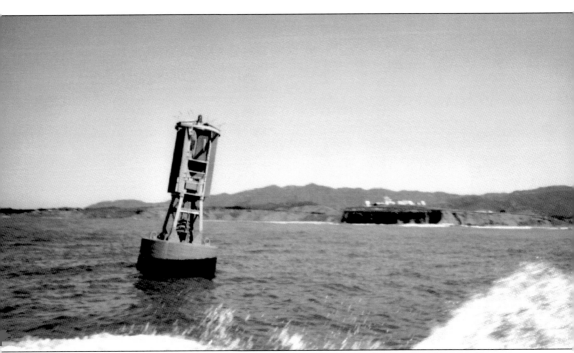

In addition to fog signals and lighthouses, buoys have been installed around Half Moon Bay since the 1880s to mark the edges of reefs. (Courtesy author.)

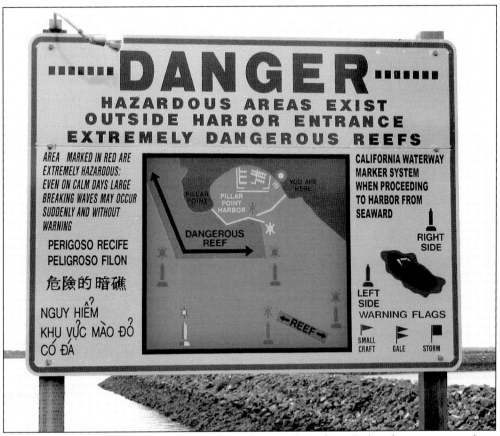

A sign has been posted at Pillar Point Harbor, where seafarers launch their boats, to warn them of the dangerous reef. (Courtesy author.)

In 1933, a ship-to-shore radio station south of Half Moon Bay was built. The station was named after John William Mackay, a wealthy miner from Virginia City who liked to buy radio stations. Located on a 200-acre parcel west of Highway 1, this receiver station is built near a cliff edge, 120 feet above the ocean. Today this station, whose call letters are KFS, is operated by Globe Wireless. (Courtesy author.)

Fog has also been a hazard for aircraft making their approach to the Half Moon Bay and San Francisco International airports. Rudimentary navigational aids were not always dependable as aircraft flew over the coastal mountain range. On Christmas Eve in 1943, a U.S. Army Air Corps four-engine bomber crashed on Star Hill Road on Kings Mountain. Its crew did not survive. The worst airplane disaster on the San Mateo coast occurred in 1953 when an airline crashed on Kings Mountain. All 19 crew and passengers perished. Fourteen years later in August 1967, a U.S. Air Force F-4 jet fighter crashed into Tunitas Creek, a little west of the 1953 airline crash. The two-man crew was able to parachute to safety. (Courtesy L. Smookler.)

Dense fog on San Mateo's coast roads has also plagued automobile drivers. Slowing down and following the white fog line (when there is one) has not always saved drivers. (Courtesy J. Hillyer.)

Three

COASTAL ACCESS

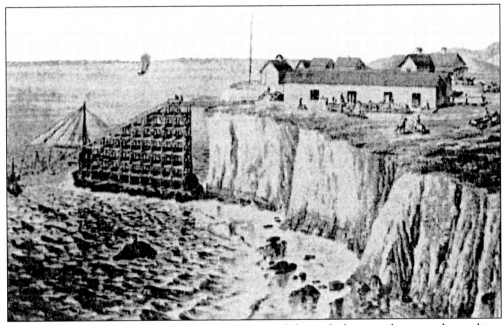

Chutes, or wooden ramps, were built on cliff tops to slide goods down to the sea and into ships. Coastal access has been limited because there are no deepwater harbors on the San Mateo coast. One such chute was built in 1870 at Tunitas Creek by a farmer named Alexander Gordon. He erected a 45-degree angled chute from the top of a steep cliff to within 50 feet of the sea; however, this tall wooden ramp was not very practical. Conditions had to be ideal for ships to be loaded—high tides and calm seas, which was not always the case. Another problem was fire. Some burlap sacks of grain and potatoes sped down the chute so fast that they caught fire and endangered the ship below. The chute had a short lifespan, being destroyed in 1885 by a southeast gale. High winds and breakers washing over the chute caused it to collapse. Other attempts to load cargo included using slings and hawsers as well as piers that sometimes extended over 2,000 feet from the shore—Henry Cowell's 1902 pier at Princeton; John Patroni's 1915 pier, which was 540 feet long; and two piers at Amesport Landing. The first pier at Amesport Landing, built in 1867 by J. P. Ames, washed away in 1900. A second pier built shortly afterward was 2,200 feet long, before it was shortened to 500 feet. The pier featured a rail line to move grain and vegetables. The Amesport Pier survived until the 1930s. Interestingly, in 1906, the Amesport area was renamed Miramar. (Courtesy J. Wagner.)

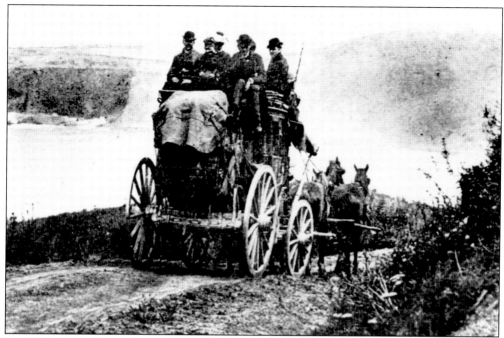

In 1873, the northbound stage approaches the Gordon Chutes at Tunitas Creek. Thirty years later, Tunitas Creek was the end of the tracks for the Ocean Shore Railroad. The stagecoach was replaced with a car to transport passengers. (Courtesy A. Baccari.)

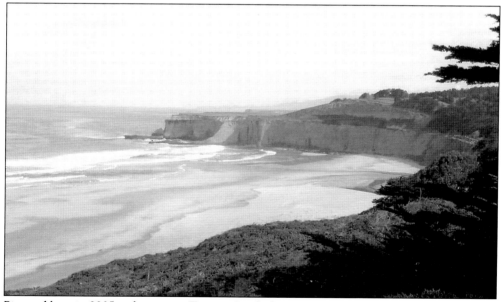

Pictured here in 2005 is the cove at Tunitas Creek. (Courtesy author.)

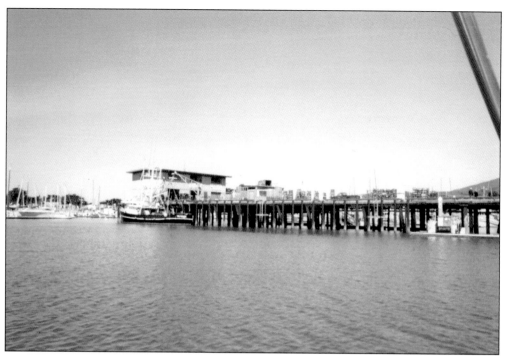

There are only two functioning piers on the San Mateo coast today. One of the largest commercial fishing boats on the San Mateo coast is Captain Morgan's black-bottom boat, pictured here docked at the Princeton pier, the heart of San Mateo's harbor. (Courtesy author.)

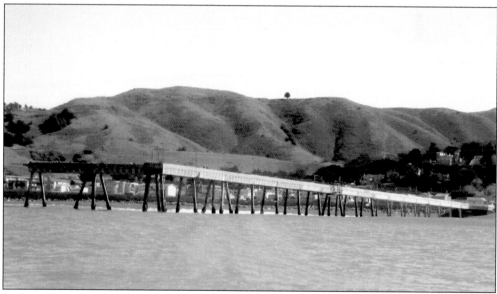

Built in 1973, the concrete Pacifica fishing pier is observed from the sea. (Courtesy author.)

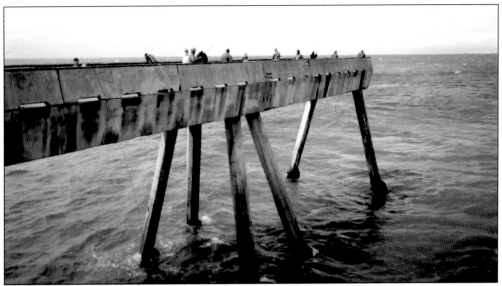

Before this pier was built, the nearby beach was the site of early roadhouses. (Courtesy author.)

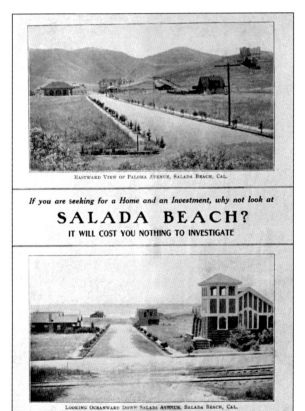

EASTWARD VIEW OF PALOMA AVENUE, SALADA BEACH, CAL.

If you are seeking for a Home and an Investment, why not look at

SALADA BEACH?

IT WILL COST YOU NOTHING TO INVESTIGATE

LOOKING OCEANWARD DOWN SALADA AVENUE, SALADA BEACH, CAL.

As early as 1873, people began talking about building a railroad from San Francisco to Santa Cruz. But it wasn't until 1905 that the Ocean Shore Railroad Company was launched. There was an abundance of agriculture goods, lumber, and mineral products waiting to be shipped from the isolated San Mateo coast. Speculators also knew that a railroad on the coast would mean a real estate boom for them. Coast communities, such as Salada Beach, Montara, and Half Moon Bay, would open up and flourish with a railroad. Salada Beach was one of nine communities later incorporated into the City of Pacifica. (Courtesy A. Baccari.)

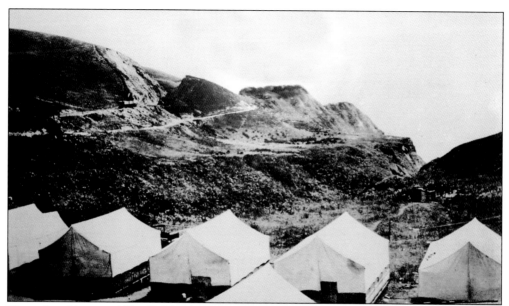

The railroad line would be 80.26 miles long and most of it would be built on the San Mateo coast. Engineering surveys showed that, in some places, the railroad would be built on extremely unstable ground. But that didn't stop the building of the railroad. Construction was simultaneously initiated from San Francisco and Santa Cruz. Around 1906, sleeping quarters for railroad construction workers were erected between San Pedro Point and Farallon City. (Courtesy A. Baccari.)

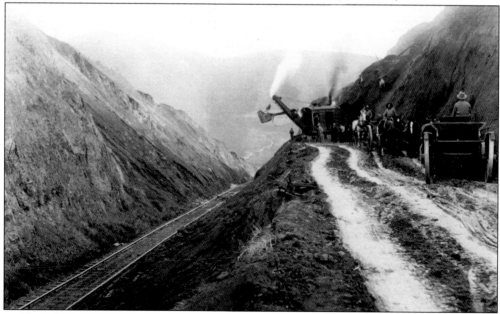

Problems for the railroad began before the first train reached Montara in 1908. From San Francisco, the railroad was on solid ground until it reached Thornton Beach in Daly City. At Thornton Beach, the railroad tracks were built on steep, sandy slopes above the ocean. From there the tracks continued onto the rocky shale and granite rock of Devil's Slide. In this photograph, workers are widening the cut in Green Valley between San Pedro Point and Farallon City. (Courtesy A. Baccari.)

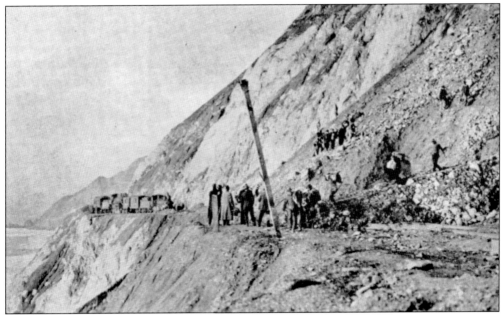

The 1906 earthquake caused landslides on Devil's Slide and closed the rail line. Though the tracks were rebuilt and trains began traveling southward, landslides, floods, and other costs prevented the completion of the line. The tracks did reach 38 miles from San Francisco to Tunitas Creek and 12 miles from Santa Cruz to Swanton. (Courtesy A. Baccari.)

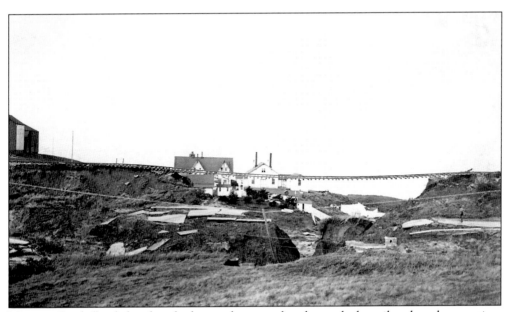

Montara Creek flooded and washed away the ground underneath the railroad tracks sometime between 1907 and 1919, as shown in this westward-facing photograph. Point Montara Lighthouse buildings are on the shore side of the tracks. A trestle was later built to support the tracks. (Courtesy F. Bezek.)

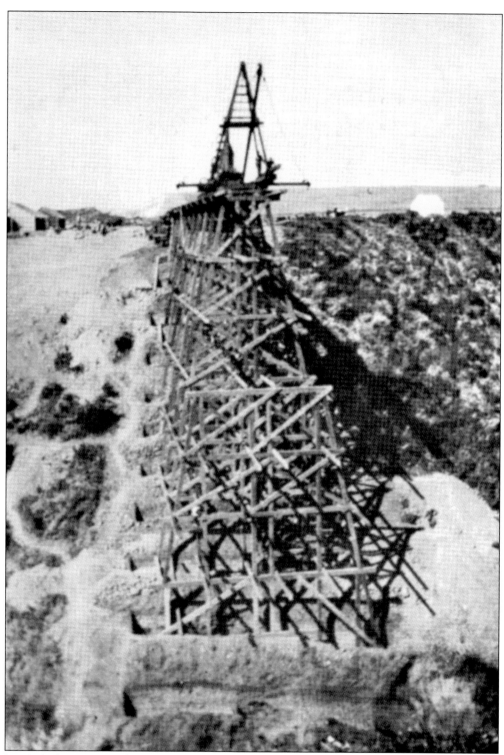

In 1906, the train trestle is being built at Lobitas Creek. Because the railroad was built parallel to the coast, the route cut across streams and arroyos. (Courtesy A. Baccari.)

The railroad proved to be a boon for lumber mills and farmers, who were now able to ship their products off the coast to local markets. The railroad enabled farmers to switch from expensive cattle to agricultural crops, reaping more profit from less investment. Farmers were most upset when the railroad went out of business. Logging and mills, such as the Shelton (Purdy) Phares Shingle Mill built at Purisma Creek in 1882, took advantage of the railroad to move their products. (Courtesy A. Baccari.)

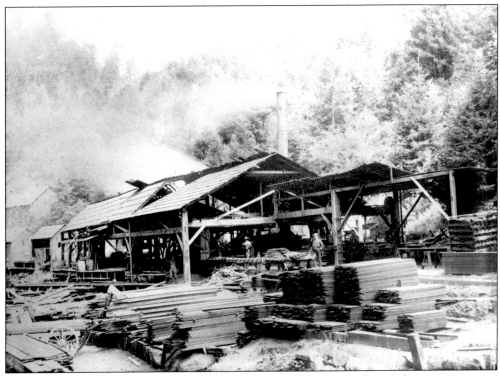

Seen here in 1894 is Saunder's Mill at Tunitas Canyon. (Courtesy A. Baccari.)

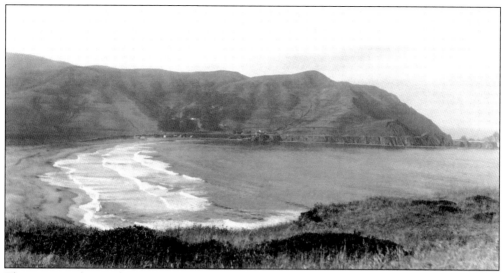

This 1907 Linda Mar (present-day Pacifica) view looks south to the ledge where the railroad bed is seen running east to west and around this point southward. San Pedro rock is on the extreme right of the picture. Notice the absence of trees. (Courtesy R. Guy Smith.)

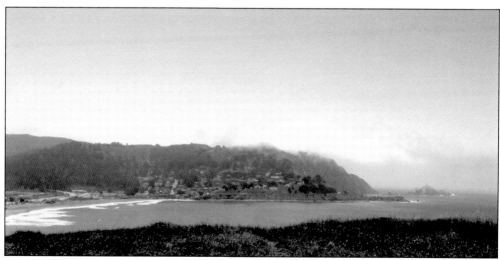

In 2005, this is the same view of Linda Mar. Notice the trees, homes, and fog. (Courtesy author.)

The train also carried passengers and land speculators, who helped to open up the isolated coast. Hotel owners on the coast attracted customers when hotels in San Francisco were booked during the 1915 Panama–Pacific Exposition. The Montara Inn, built in 1909 on the slopes of Montara Mountain, overlooked the Pacific Ocean. (Courtesy A. Baccari.)

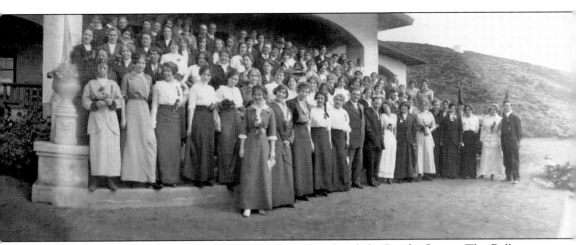

Guests at the Montara Inn look west toward the railroad and the Pacific Ocean. The Balboa sisters are pictured in the front row on the far right. (Courtesy R. Guy Smith.)

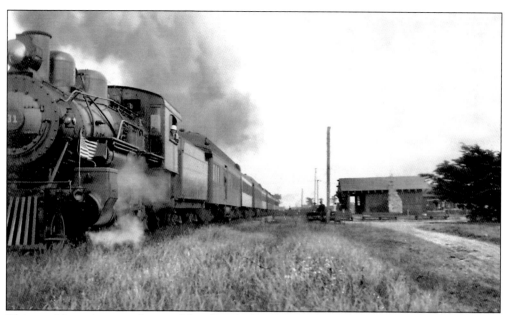

This northbound train is leaving Moss Beach. (Courtesy R. Guy Smith.)

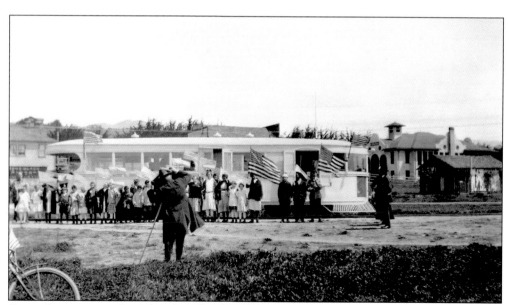

Costs of maintaining the railroad escalated, and the company looked to cut expenses. Alternative-powered railcars were tried. The Ocean Shore Railroad also tried a variety of self-propelled railcars. The above 1918 photograph shows a gasoline-electric powered combination coach in Moss Beach. The two-story Moss Beach schoolhouse is on the right. (Courtesy R. Guy Smith.)

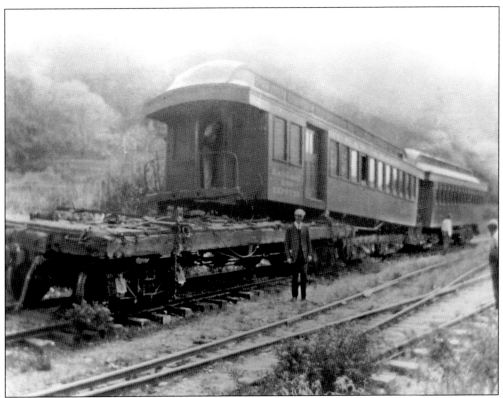

In 1915, this train wreck occurred near Swanton. There were no fatalities from the occasional slides and other mishaps that plagued the railroad. (Courtesy A. Baccari.)

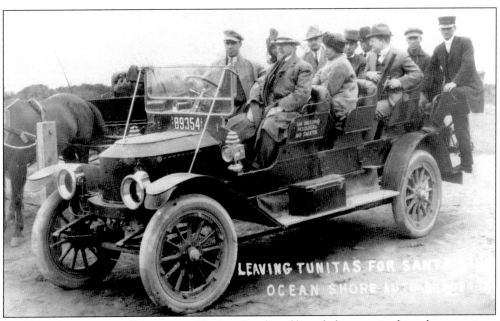

In 1908, passengers got off the train at Tunitas Creek and boarded a motorized coach to continue to Santa Cruz. (Courtesy A. Baccari.)

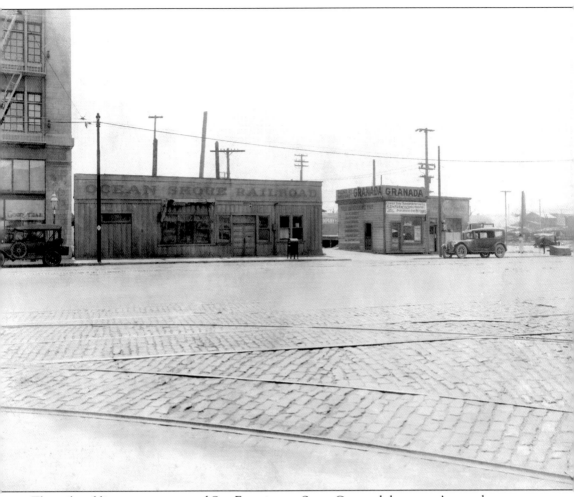

The railroad line never connected San Francisco to Santa Cruz and there wasn't enough money to save the line. When railroad engineers asked for an increase in their wages in 1920, they were told no by the board of directors and the railroad went out of business. This June 9, 1921, photograph shows the boarded-shut train station of the Ocean Shore Railroad at 1016 Mission Street and Twelfth and Otis Streets in San Francisco. (Courtesy R. Guy Smith.)

Early San Mateo county roads were few and far between. On the coast of San Mateo, trails and dirt roads were the only means of land access until 1906. Combined with adverse weather due to fog and high winds, travel was precarious and slow. Though isolated by mountains and the ocean, stagecoaches connected small towns like San Gregario and Pescadero in the southern part of the county. Primitive coast roads were also to blame for the odd shape of the southern end of San Mateo County. According to Jack Olsen, the coast road in this area before 1886 was basically on the beach and in stormy weather some farmers who lived in Santa Cruz County could not reach the county seat in Santa Cruz. These farmers decided they wanted to be part of San Mateo County instead. The county line was redrawn in 1877 based upon who wanted to be in San Mateo and those who wanted to stay with Santa Cruz.

Pictured here in 1886, in no particular order, are Cecil Levy, Margaret Chrisman, Armand Levy, the driver, and several unidentified people. (Courtesy A. Baccari.)

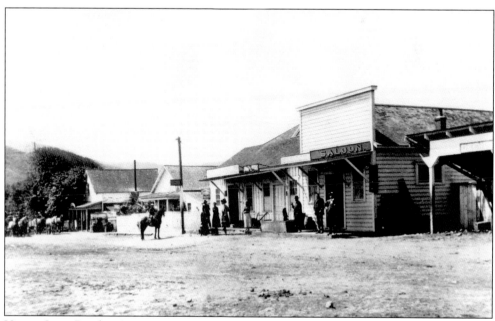

Here is Stage Road in San Gregorio in 1887. (Courtesy A. Baccari.)

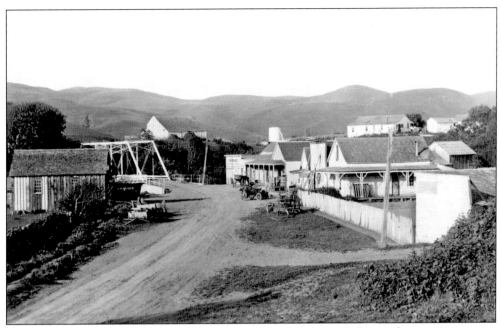

In 1910, cars began to replace horses in San Gregorio. (Courtesy A. Baccari.)

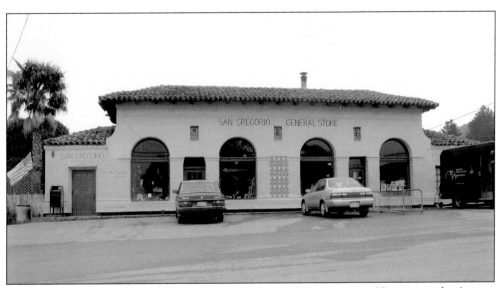

Since 1889, San Gregorio General Store has been serving the community. (Courtesy author.)

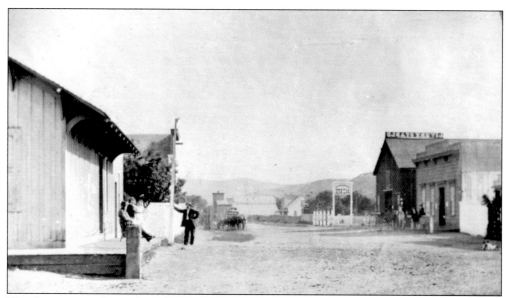

The sleepy town of Pescadero, shown here between 1860 and 1870, was founded in 1856. (Courtesy A. Baccari.)

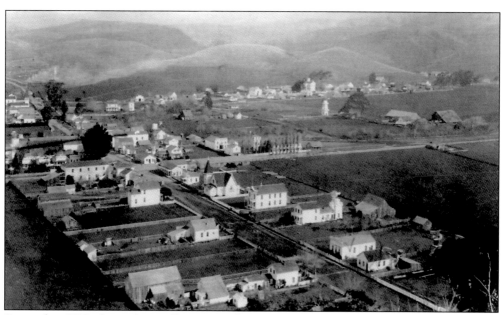

Pictured in 1890, this is the small, countryside town of Pescadero. (Courtesy A. Baccari.)

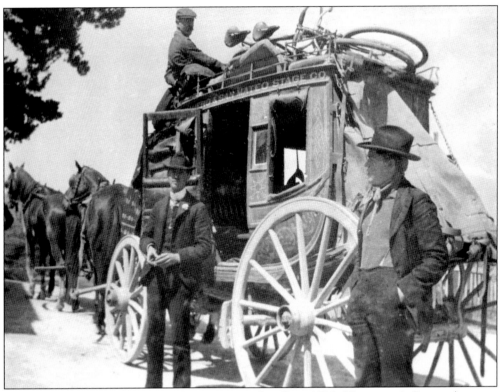

The Pescadero–San Mateo Stage Company stops briefly in 1890. (Courtesy A. Baccari.)

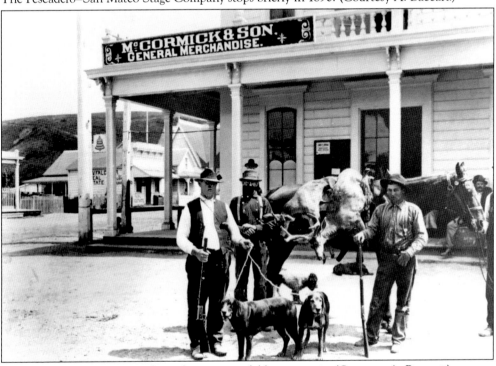

In 1896, men return to Pescadero after a successful hunting trip. (Courtesy A. Baccari.)

A car is parked north of the Moss Beach train station. (Courtesy R. Guy Smith.)

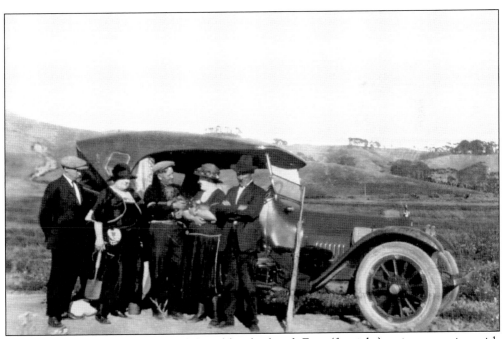

Marie Kullander (second from right) and her husband, Fritz (far right), enjoy an outing with friends in Montara. Drivers on San Pedro Mountain Road had to navigate not only hairpin turns, but thick fog. Sometimes they stopped their cars and got out to see if they were still on the road. Until 1937, this road was in use. (Courtesy J. P. Ruschmeyer.)

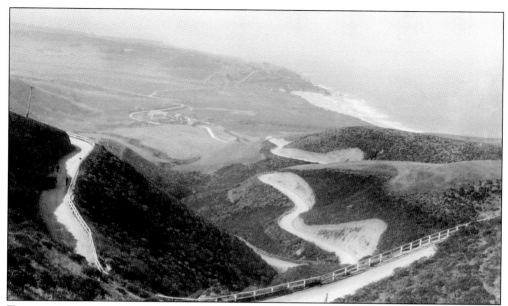

Train service was supposed to improve access to the area, but delays, intermittent service, and the popularity of the automobile soon brought the construction of paved roads along the San Mateo coast from San Francisco to Santa Cruz. A paved road, for example, was built in 1915 over Montara Mountain. This photograph is the road on the Montara side of the mountain. Much of the old road is still in pretty good condition 68 years later, but is only used by hikers and bicyclists today. (Courtesy A. Baccari.)

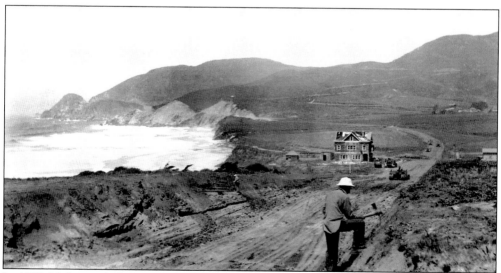

In 1937, 30-foot wide $400,000 California State Highway 56 was built through Montara. The building in the middle of the photograph is Robert Gallagher's summerhouse. North of his house is the south end of Devil's Slide. (Courtesy R. Guy Smith.)

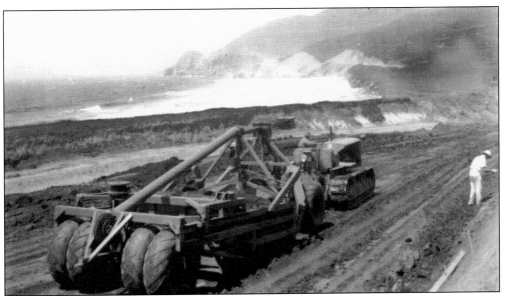

Here 1936-era construction equipment is grading the coast highway. Routes of some county highways changed from inland routes through towns (e.g. Half Moon Bay's Main Street) to roads closer to the ocean. Also, until 1960, what is known today as California State Highway 1, used to be California State Highway 56. Another San Mateo County road, Highway 35 (Skyline), was rerouted from east of San Andreas Lake to the crest of the coast mountain range. Until the early 1960s, it was called State Highway 55. In 1926, state highways began to be numbered. (Courtesy R. Guy Smith.)

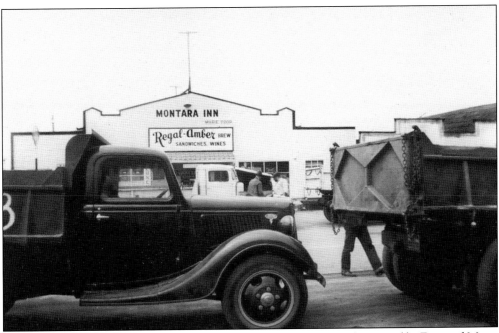

Dump trucks park in front of the Montara Inn, which was owned and operated by Fritz and Marie Kullander. Fritz built the inn in the late 1920s. (Courtesy J. P. Ruschmeyer.)

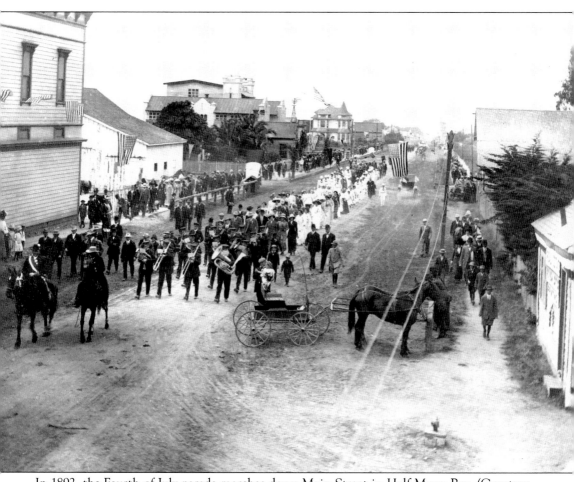

In 1892, the Fourth of July parade marches down Main Street in Half Moon Bay. (Courtesy A. Baccari.)

This 1941
county defense map
shows the routes of
county roads.

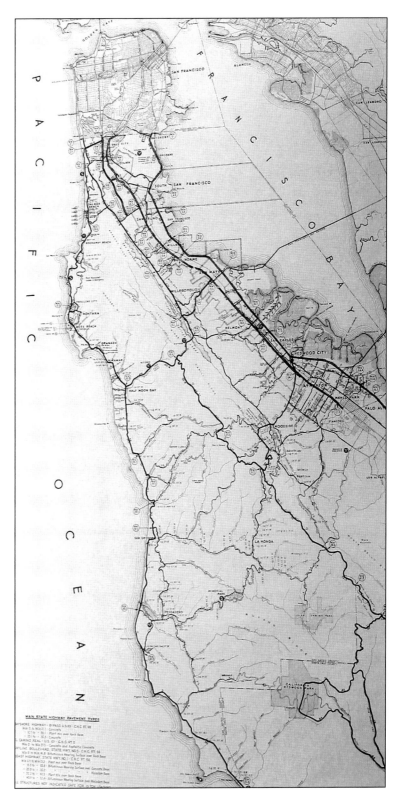

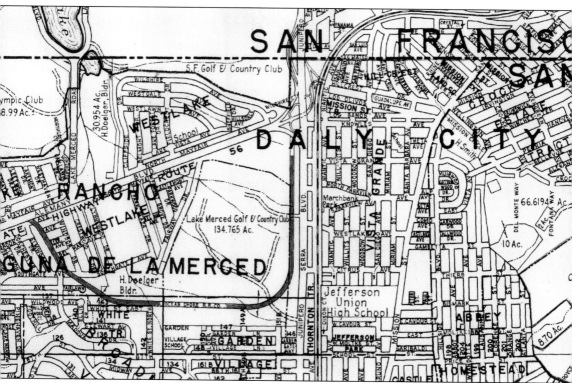

Before John Daly Boulevard and Interstate Highway 280 were built in San Mateo County, one could see the right of way for the Ocean Shore Railroad on Daly City maps—dark black road from the "A" in Daly down and west under De La Merced. (Courtesy Bunny Gillespie.)

Four

EARLY COASTAL ATTRACTIONS

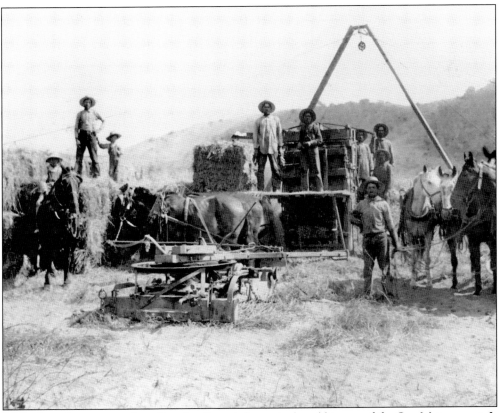

A fertile geologic terrain has directly affected the agricultural history of the San Mateo coast. It has made raising cattle, dairies, logging, and the growing of a variety of vegetable crops possible. Early Native Americans, Mexican rancheros, and Portugese, Japanese, and Italian farmers all profited from the rich soil and the cool coastal climate. Here, in 1890, farm workers are harvesting grain near Half Moon Bay. The San Mateo County coast has drawn people to the area throughout its history because of its fertile soil for farming, rich marine life, spectacular scenic views and open space, surf and beaches, golf, isolation, and close commute to nearby metropolitan areas. (Courtesy A. Baccari.)

Oxen pulled logs from the hills south of Half Moon Bay. Farming on the coast was expensive because of poor access due to the coastal mountains and the lack of deep-water harbors. Until 1906, when the Ocean Shore Railroad began to operate, it could take farmers sometimes two days to ship their products in and out of the coast. Beef and dairy cattle became too expensive to raise. Eventually coast farms turned to growing flowers and vegetable crops such as brussels sprouts and artichokes.

By 2004, according to Jack Olsen at the San Mateo County Farm Bureau in Half Moon Bay, 90 percent of the county's $200 million annual agriculture industry is on the San Mateo coast.

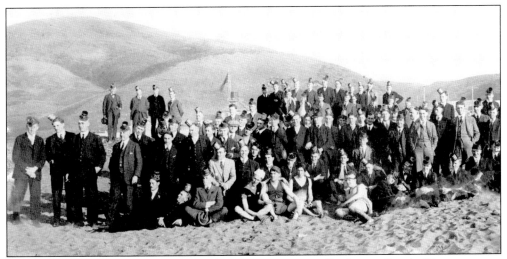

In 1926, the California Fruit Growers Association meets at Rockaway Beach. The event was called Musselbust. Flowers, vegetables, cattle, and lumber have made up the coast's trade for 100 years. (Courtesy A. Baccari.)

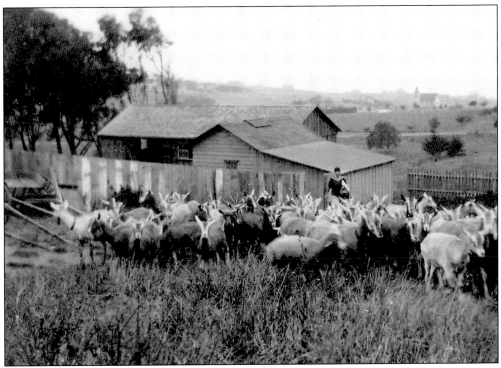

Dairies once dotted the coast from John Daly's ranch in the north to the Steele family's dairy at Año Nuevo in the south. Morris Wagner was a postmaster and, between 1915 and 1925, owner of a 200-goat dairy in Montara. Except for a small goat dairy that began in 1997, there are no longer any dairies in San Mateo County. (Courtesy R. Guy Smith.)

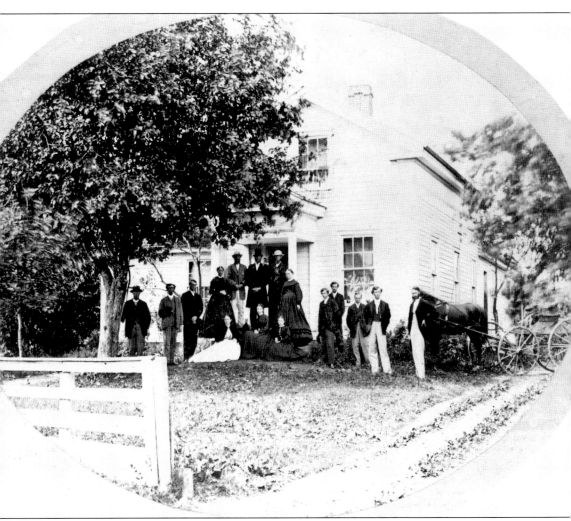

In 1861, the Steele family started the Cascade Ranch near Año Nuevo. Photographed in 1870, the Steeles were a prominent family in the area. One brother, Fredrick Steele, was a major general in the Union Army. During the Civil War, General Steele arranged for an entire day's production of his family's dairy to make the largest piece of cheese in the country. The cheese weighed two tons and was sold at auction in San Francisco for one dollar a pound. The money was donated to the Sanitary Service, forerunner of the Red Cross. A sample of the cheese was also sent to President Lincoln. By the 1940s, the Steele dairy business switched to row-crop farming. This was a time of home-front labor shortages brought on by World War II. As a result, the Bracero program was started in 1942 to help farmers. In 1986, the Steele farm became a state conservatory. The state promised to build a reservoir on the property to provide a sufficient supply of water for irrigation so the farm could continue farming 500 to 600 acres a year. But the reservoir was never built, and only 50 acres are farmed today. (Courtesy A. Baccari.)

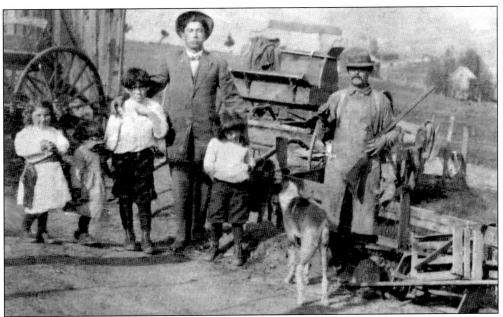

In 1906, Ulyssie Marsigli arrived in San Francisco from Italy on the day of the earthquake. Shortly after, he bought land in Montara to farm. Locals said that Marsigli farmed all the land that no one occupied. He grew artichokes, brussels sprouts, and other crops. In 1913, Ulyssie, his family, and a ranch hand get ready to work. His farmhouse, in which four of his children were born, is still standing on the 1300 block of Cedar Street in Montara. His 87-year-old son Leevio is alive and well and living in Colma. (Courtesy L. Marsigli.)

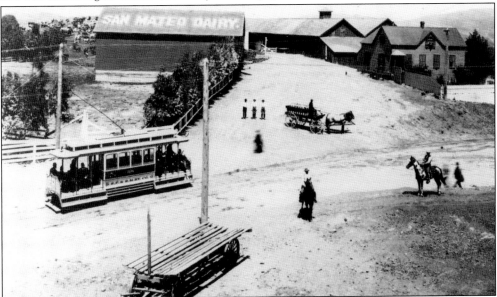

In some areas, farmers sold their lands for housing subdivisions. John Daly, who had operated a large dairy ranch in the northern part of San Mateo County since the 1880s, realized after the 1906 earthquake that selling his land for houses was more profitable than his dairy. John had provided use of his dairy, seen here in 1898, and food for refugees of the San Francisco earthquake. His old dairy land became part of Daly City. (Courtesy A. Baccari.)

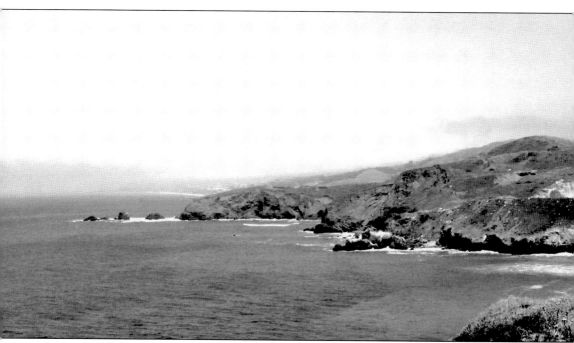

The ocean off the San Mateo coast is a migration route for humpback and gray whales. Whales are attracted to this coast because of the abundance of krill and barnacles on promontories of rock. Krill are small-like animals that concentrate near the edges of underwater canyons. They are the only food eaten by blue whales. Today visitors flock to cliff tops and lighthouses to enjoy the view of these mighty leviathans between December and April. Here promontories of rock jut out from the coast and often draw migrating whales close enough to scrape off barnacles. Submarine canyons, cold water, rocky underwater clefts, and promontories of rock jutting out into the sea, attracts sea life. Whales, sharks, halibut, mussels, clams, monkey face eel, rock scallops, link cod, octopus, salmon, urchins, crabs, whales, seals, sea otters, and abalone are but a sampling of the local marine life.

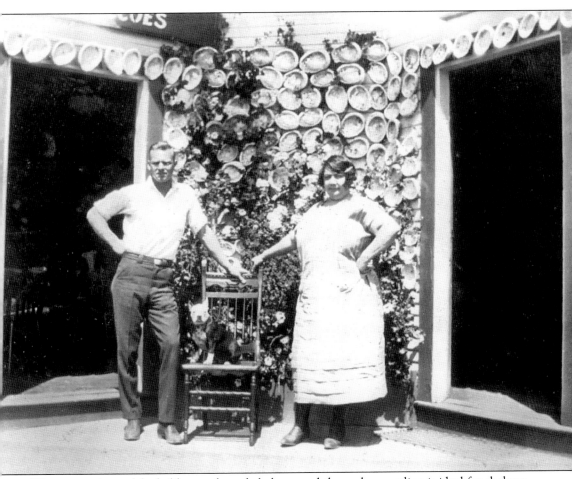

Warm water is good for halibut, crab, and abalone, and the rocky coastline is ideal for abalone fishing. In the 1940s, abalone fishing started to get big because of hard-hat divers. Before then, divers had to use hooks, which was a very slow process. Abalone were once very plentiful. Local restaurants served abalone, and shells decorated many establishments. Here are Gus Pope and Marie Kullander in front of the Montara Inn about 1935. (Courtesy J. P. Ruschmeyer.)

Like oysters, abalone have pearls. A collection of these pearls and brass fittings were found by diver Ferris Hix.

Abalone have their fame on the San Mateo coast. The world record abalone—$12\frac{5}{16}$ inches long and $9\frac{3}{4}$ inches wide—is on display in the store at Martin's Beach. Caught on March 13, 1994, by local sport fisherman John Pepper, its shell and meat weighed $11\frac{1}{2}$ pounds (the shell was five pounds). John is photographed holding a tape measure across his abalone. The peak time for abalone fishing on the San Mateo coast was in the 1950s and 1960s. However, since 1998, abalones are not permitted to be caught from the south tower of the Golden Gate Bridge to the Mexican border.

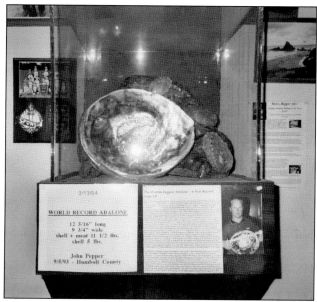

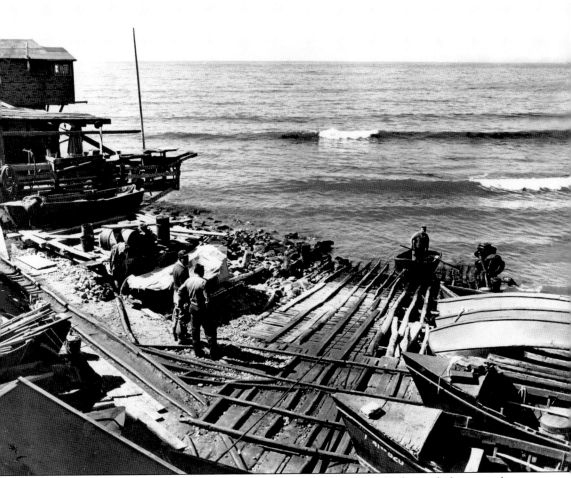

Whales are common sights off the San Mateo coast, but divers usually hear whales more than they see them—sound travels five times faster under water than on land. Seals are also plentiful and very curious and pesky, taking fish right off divers' spears. In 1939, this was the San Pedro pier. (Courtesy A. Baccari.)

The San Mateo coast has been repeatedly damaged with oil spills and mud. In the mid-1980s, the Port of Oakland planned to dump mud dredging six miles off the coast of Montara. Local fishermen were up in arms. But their protests that the mud would decimate the local marine life fell on deaf ears with Port of Oakland officials. Fishermen suggested an alternative dumping ground: dispose of the mud on top of government barrels that were dumped on the sea floor off the Farallone Islands. The Port of Oakland did not agree. Then, Don Pemberton, a local commercial fisherman since his 1976 college graduation, had a bold idea. Don loaded 4,000 pounds of fish heads on a flat bed truck and hauled them to the Port of Oakland offices. He said if the port was going to dump mud in his backyard, then he was going to dump fish heads in front of their offices. Local television coverage of the fish head incident and a threatened lawsuit convinced the port to change its mind. According to many longtime local fisherman, the Clean Water Act enacted in 1998, has improved fishing on the San Mateo coast. From 2000 to 2005, there has been better crab and salmon fishing than between 1980 and 2000.

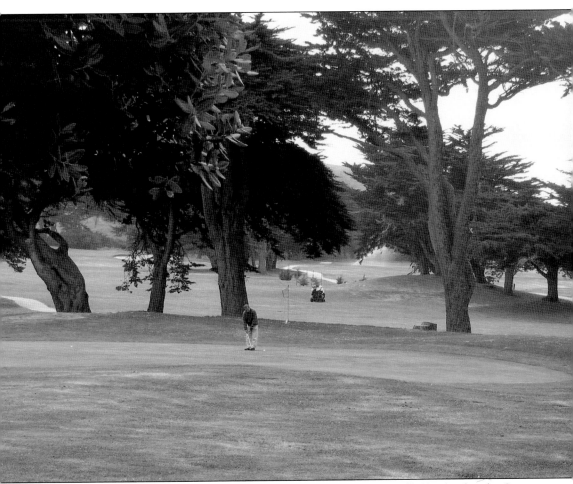

In the early part of the 20th century, an artichoke farmer named Sharp willed his land to the City of San Francisco with the provision that the land could only be used for recreational purposes. In 1930, the city built the Sharp Park Golf Course on the farmland. Though now located in the City of Pacifica, this public golf course is still owned by the City of San Francisco.

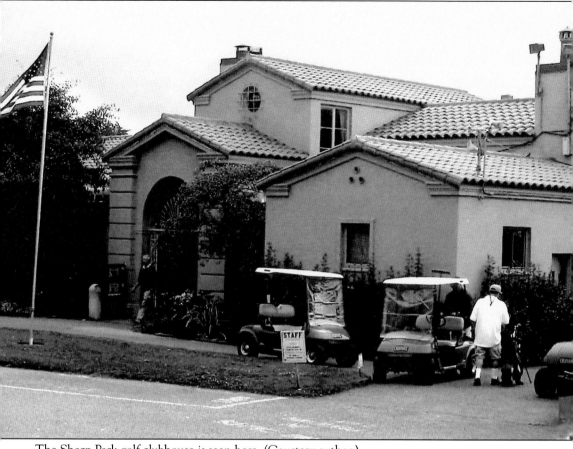

The Sharp Park golf clubhouse is seen here. (Courtesy author.)

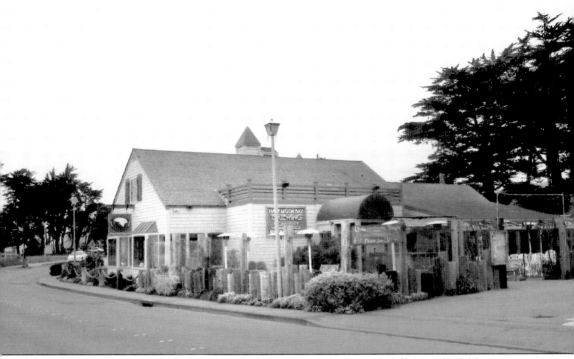

Other golf courses were built or proposed to be built on the coastal cliffs. A golf clubhouse was constructed by Deane and Deane in Princeton for a course that was later cancelled. Formerly the golf clubhouse, then the Shorebird restaurant, and today known as the Half Moon Bay Brewing Company, this popular brewery faces Princeton Harbor. Before the brewery was built, a roadhouse sat on this site. It was known as Nerli's. Ray Martini said that his father serviced slot machines in the back room at Nerli's. (Courtesy author.)

Pictured in 2005, Moon Mullins, a golf pro who Deanne and Deanne brought from Palm Springs, helped design the golf course. After Deanne and Deanne left, Moon stayed. (Courtesy author.)

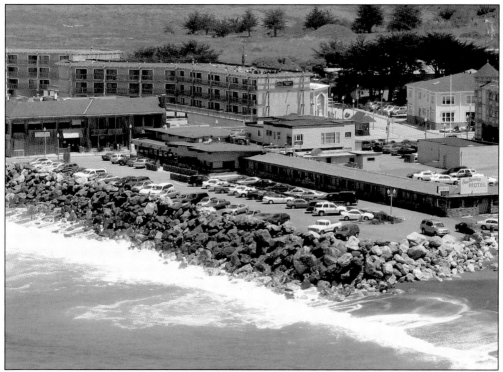

According to 84-year-old Ray Martini, there seemed to be more bars and restaurants on the coast than people. Ray, who was born in the back of this father's store and bar, which is still standing at the corner of Etheldore and Sunshine Valley Road in Moss Beach, said that it was too hard to drive over the hill for a drink or to meet people; it is like what a drive to Reno from Moss Beach would seem like today. The isolating mountain range meant that many of these establishments were erected from one end of the coast to the other and some are still in business in 2005. Since it was built in 1927, guests have watched the high surf lashing the shores in front of Nick's Restaurant at Rockaway Beach in Pacific. Nick's and the Sea Breeze Motel are in the foreground. Riprap provides some protection for the restaurant and motel. (Courtesy author.)

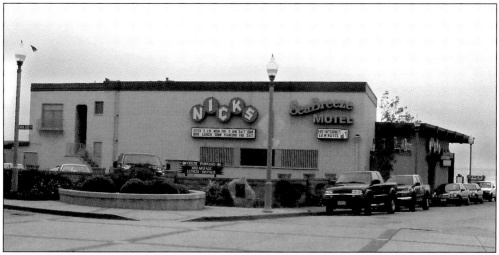

Nick's Restaurant is pictured here on a typical coastside day. (Courtesy author.)

Nestled on the hill and just south of Nick's on the east side of Highway 1 is the Beach Hotel and Restaurant. A stylized statue of the early explorer Capt. Gaspar Portola is on the left. (Courtesy author.)

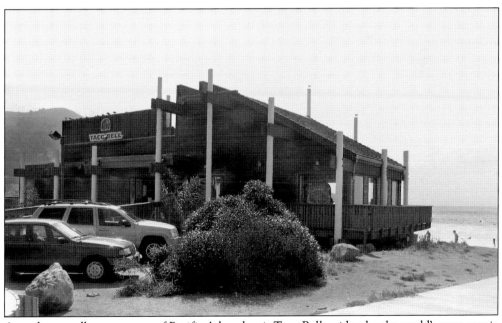

A modern roadhouse on one of Pacifica's beaches is Taco Bell, said to be the world's most scenic one. (Courtesy author.)

The surf along the San Mateo County coast has attracted surfers for many years. From the deck of Taco Bell, visitors can watch surfers.

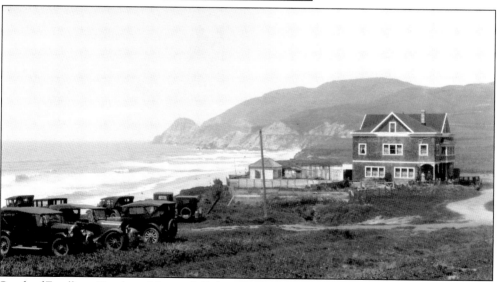

South of Farallone City (now Montara), Robert Gallagher converted the summerhouse he built in 1913 into the Montara Beach Hotel in 1921. The U.S. Navy used the hotel for billeting personnel from the nearby gunnery school during World War II. After the war, the hotel burned. (Courtesy J. P. Ruschmeyer.)

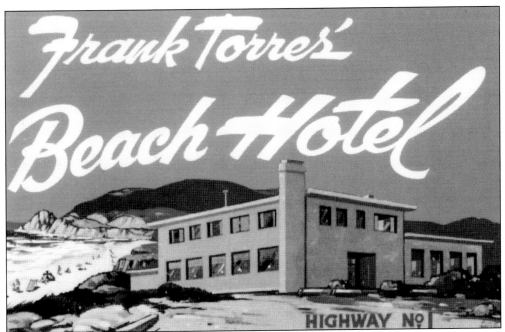

Frank Torres built a new hotel and restaurant, the Frank Torres Beach Hotel, on the same site after the war. Frank was from Peru, and the specialty of his pink painted house was Peruvian cuisine. (Courtesy J. Hillyer)

Room keys from Frank Torres Beach Hotel, and bar tokens from a later restaurant that replaced Frank's are shown here. (Courtesy J. Hillyer)

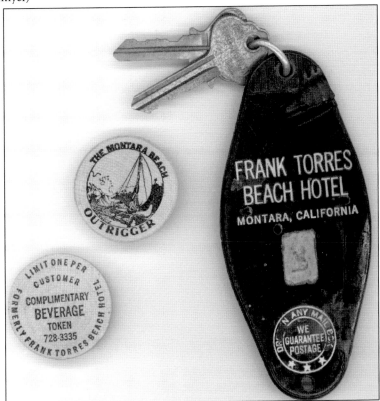

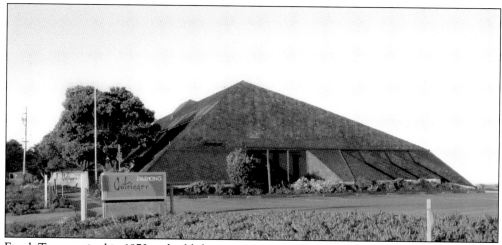

Frank Torres retired in 1970 and sold the property to the Chart House restaurant chain. Frank's hotel was torn down and replaced with the Chart House. A condition of the construction permit for this structure was that the public could use the restaurant's parking lot for beach access during the day until the state built a separate lot. However, the state never built the lot. The restaurant could not serve lunch because so many people wanted to park there. Without a lunch crowd, the restaurant could not sustain itself. The Chart House finally closed. A restaurant known as the Outrigger opened under new owners, but this too closed. The 11,000-square-foot structure reportedly is a second home for a family. (Courtesy author.)

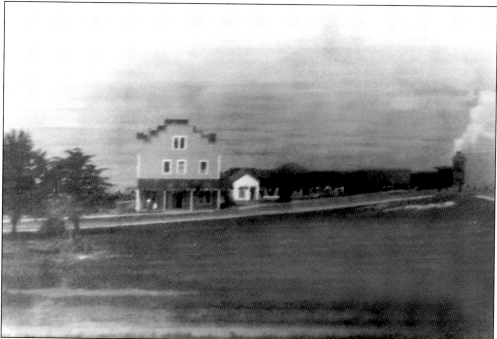

Across the street on the east side of the Ocean Shore railroad tracks and an eighth of a mile south of Gallaghers, was the Farallon Hotel, built in 1906 by John A. Flink. In this picture, a northbound train is traveling through Farallone City past the Farallon Hotel. Ownership and use of the hotel has changed several times—as a restaurant and a house of ill repute in the 1940s. Today it is a bed and breakfast known as the Farallone Inn. (Courtesy F. Bezek.)

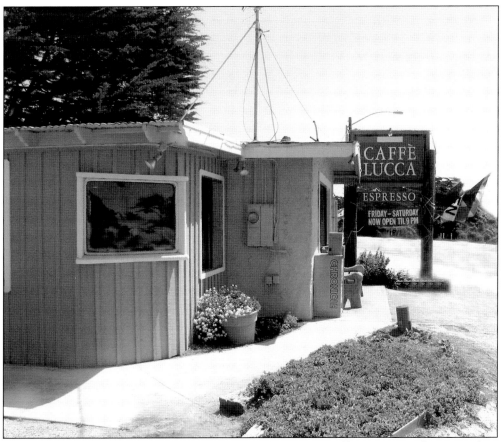

On the same side of the street, just south of the Farallon Inn, is Caffe Lucca, a small espresso shop that faces the Pacific Ocean. Caffe Lucca occupies a structure that has also seen many tenants over the years. (Courtesy author.)

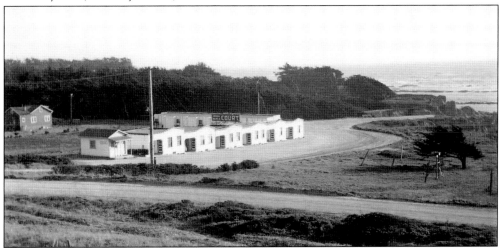

Across the highway in neighboring Moss Beach was Dan's auto court. Built near the ocean cliff edge, this is Dan's Auto Court in 1938. The auto court was torn down in the mid-1980s and replaced with homes by local builder Joe Gunthern. (Courtesy R. Guy Smith.)

In 1881, J. F. Wienke founded the Moss Beach community, which was south of Farallone City. In 1882, he built the Moss Beach Hotel. The hotel's restaurant featured locally caught abalone and fried chicken. The hotel burned in 1911, but Wienke Road on the west side of Highway 1 honors Moss Beach's founder. (Courtesy R. Guy Smith.)

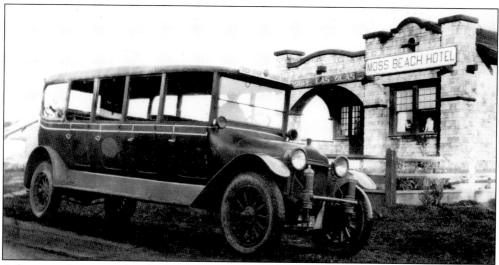

A few years later, more hotels were built in Moss Beach, including the Moss Beach Hotel and Nye's Hotel. The Red Stage Line bus parked in front of the Moss Beach Hotel sometime between 1916 and 1918 (the years the Red Stage Line was in business). The sign over the arched entrance, "Adobe Las Olas" means hotel of waves. (Courtesy R. Guy Smith.)

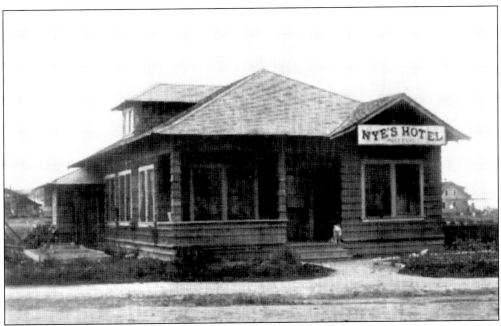

Charles Nye's hotel was built in 1920. (Courtesy R. Guy Smith.)

BOATING, BATHING, ABALONE
AND SURF FISHING

ACCOMMODATIONS FOR WEEK-END
PARTIES DANCING

NYE'S
MOSS BEACH HOTEL

CHAS. T. NYE, PROPRIETOR

PHONE MOSS BEACH 33

TRY OUR FAMOUS
ABALONE, EEL AND FISH
DINNERS

*Spend your vacation at the prettiest resort
between San Francisco and Santa Cruz*

MOSS BEACH, CAL.

At the same time, Nye was also operating The Reefs restaurant on the beach. (Courtesy R. Guy Smith.)

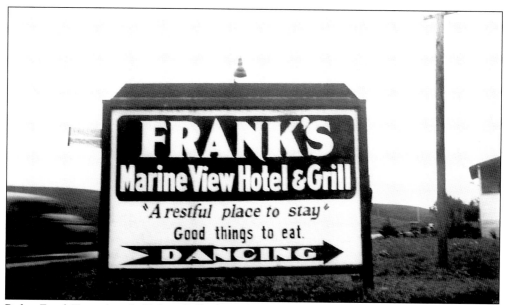

Before Frank Torres bought Robert Gallagher's place in Farallone City, he operated Frank's Marine View Hotel and Grill and the Marine View Tavern in Moss Beach. This is 1938 photograph of Frank's sign. (Courtesy A. Baccari.)

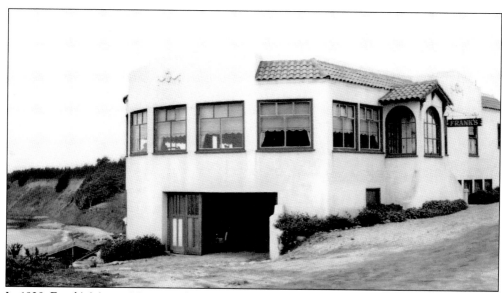

In 1928, Frank's Marine View Hotel was built. (Courtesy R. Guy Smith.)

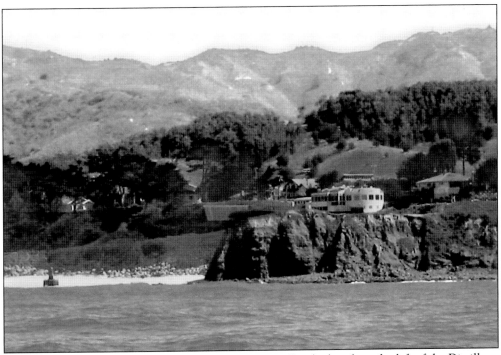

Today Frank's hotel is called the Distillery Restaurant. On the beach to the left of the Distillery, bootleggers landed their goods during Prohibition. (Courtesy author.)

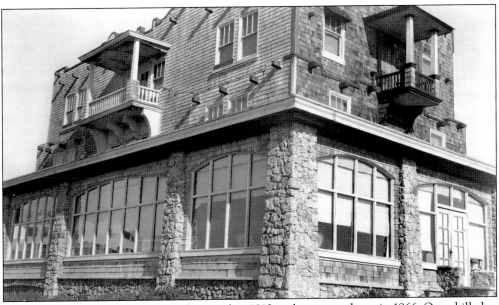

The Marine View Tavern and Hotel opened in 1913 and was torn down in 1966. Once billed as the classiest hotel between San Francisco and Santa Cruz, Frank Torres leased the tavern in 1922 for five years before he built the Marine View Hotel next door. (Courtesy R. Guy Smith.)

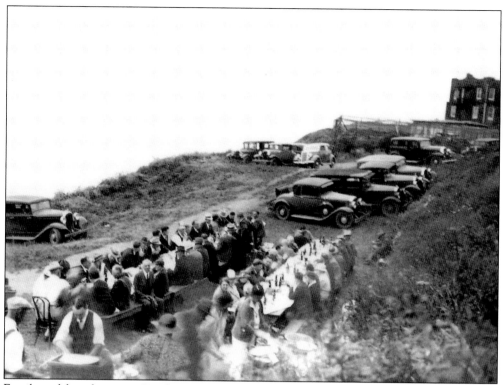

Family and friends enjoy a Sunday picnic north of the tavern. (Courtesy R. Guy Smith.)

Inside Frank's on June 3, 1938, Frank Torres is the man on the right. (Courtesy R. Guy Smith.)

Looking east toward Frank's, the tavern on the right. (Courtesy R. Guy Smith.)

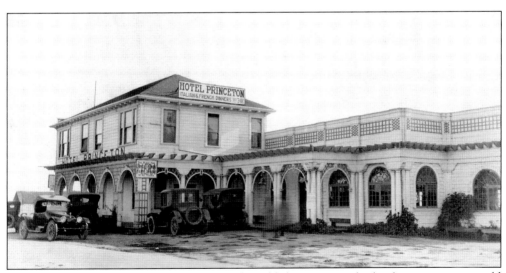

South of the Half Moon Bay Airport, several establishments were built where customers could dine and enjoy the view. In 1912, at Princeton Harbor, the Princeton Hotel was built. Some of Half Moon Bay's most well-known names helped build the hotel—Ben Cunha did the millwork and A. S. Hatch provided the lumber. (Courtesy R. Guy Smith.)

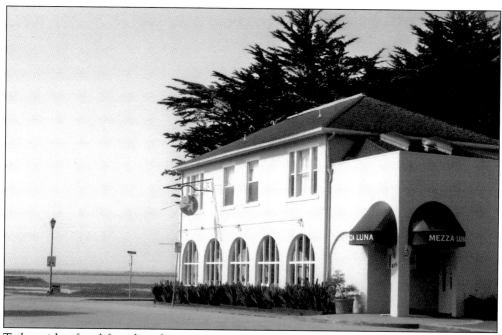

Today with a face-lift and modern interior improvements, the Princeton Inn is now called the Mezza Luna. (Courtesy author.)

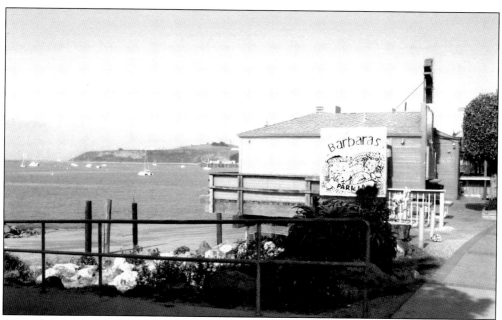

Around the corner and southeast from Mezza Luna is Barbara's Fishtrap, once known as Hazel's. Hazel's and a pier were destroyed by the 1946 tsunami. Hazel's was rebuilt into what is now Barbara's Fishtrap. Customers enjoy the view of the harbor, Pillar Point, and the Pacific Ocean. (Courtesy author.)

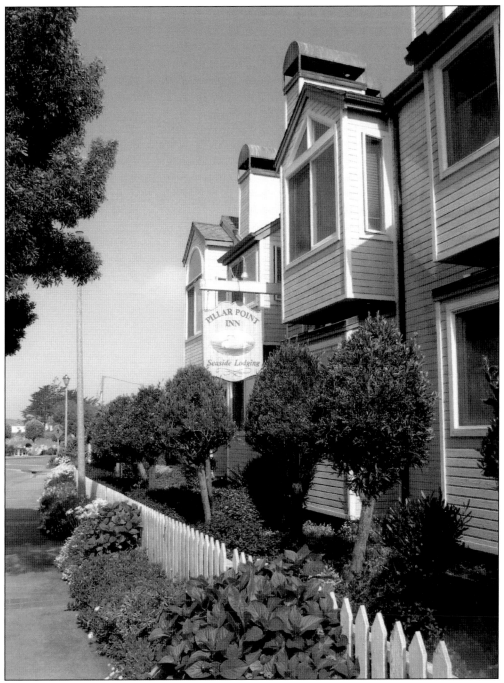

On the northeast side of the street from Barbara's Fishtrap is the Pillar Point Inn. The San Mateo coast now abounds with bed and breakfast establishments that show off a picturesque coastline. (Courtesy author.)

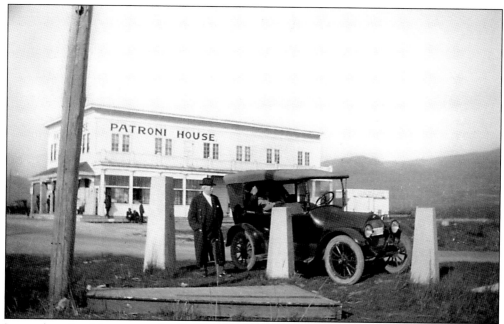

Located north of the present-day Half Moon Bay Brewing Company, the Patroni House is seen in 1925. (Courtesy A. Baccari.)

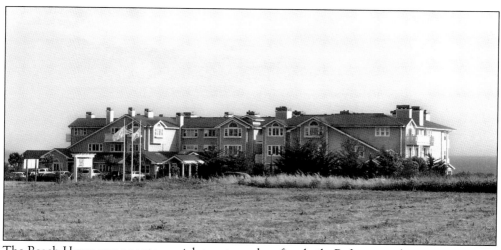

The Beach House was a controversial structure when first built. Before completion, a suspicious fire destroyed the building. Now rebuilt, it is located on Highway 1 south of Princeton.

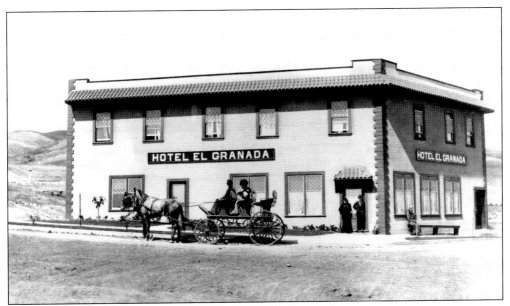

In 1896, this was the Hotel El Granada. (Courtesy A. Baccari.)

Formerly Mimi Cowley's hotel/bordello, today this structure, built around 1917, on the old highway is the Miramar Restaurant. Home to restaurants, it was also used as a grocery store and a speakeasy during Prohibition. (Courtesy author.)

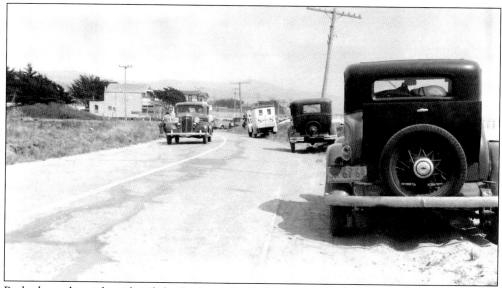

Parked on the right side of the highway near the Miramar, the third vehicle (white) on the right belongs to R. Guy Smith. He probably stopped to take this photograph. (Courtesy R. Guy Smith.)

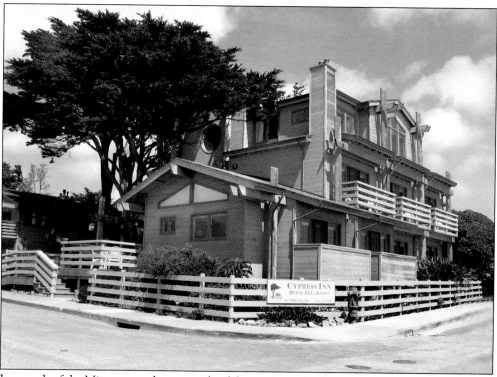

Just south of the Miramar on the same side of the road sits a bed and breakfast called the Cypress Inn. (Courtesy author.)

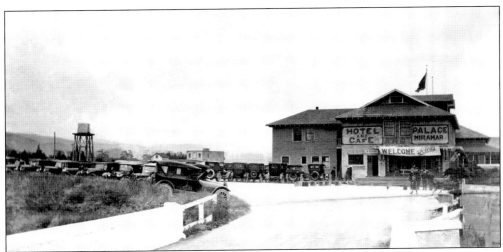

Down the road from the Miramar Inn, was the Palace Miramar Hotel, built by Joseph S. Miguel in 1916 for $30,000. It was called the most opulent hotel on the coast. During Prohibition, it was said that Miguel ran a very profitable liquor business in his hotel, seen in this 1917 photograph. Longtime resident Yola Picchi said that the palace had wonderful saltwater baths inside, which were later covered with a ballroom floor. She attended many dinners there, including ones for the local Lions club and the Little League. Big bands often came to play. The palace would have been at the end of Mirada Road where apartments are today. On the ocean side of this site at low tide, one can see remains of an old pier. (Courtesy R. Guy Smith.)

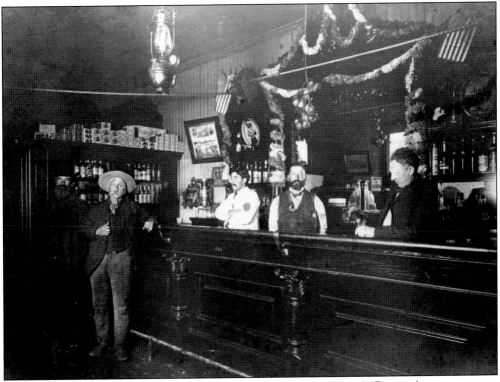

Azevedo's Saloon is seen here in 1897 in Half Moon Bay. (Courtesy A. Baccari.)

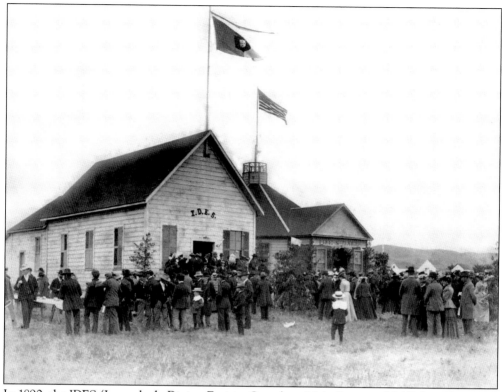

In 1890, the IDES (Irmanda do Divino Espirito Santo) on Main Street in Half Moon Bay was a gathering place for the Portuguese from the Azores. (Courtesy A. Baccari.)

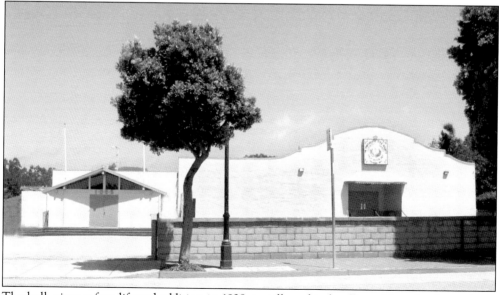

The hall, given a face-lift and addition in 1928, is still used today. Every May, the descendants of the Portuguese settlers celebrate the Chamarita Festival, the Pentecostal Festival of the Holy Ghost. (Courtesy author.)

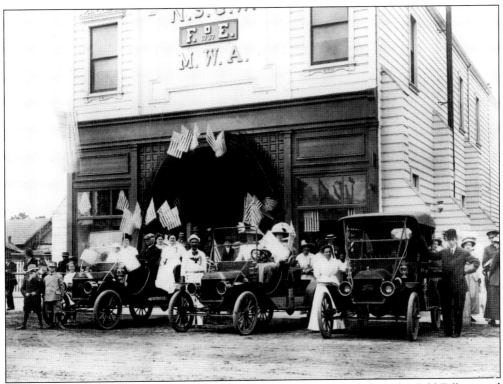

Several fraternal organizations had meeting places on the coast including the Odd Fellows and the Native Sons of the Golden West. This is a photograph of the Native Sons of the Golden West building in 1920 on Main Street in Half Moon Bay. (Courtesy A. Baccari.)

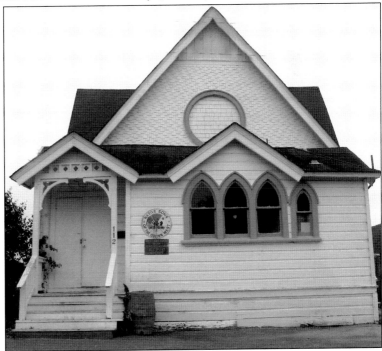

Located in a historical landmark in Pescadero is another chapter of the Native Sons of the Golden West. (Courtesy author.)

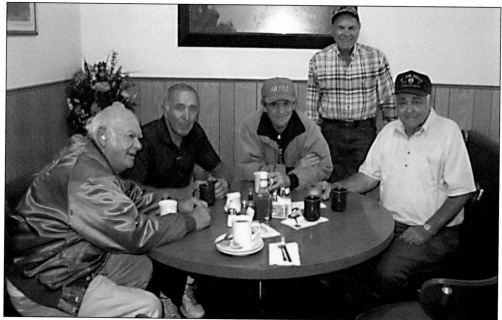

At Sam's Coffee Shop in Half Moon Bay, representing over a 100 years of coast history (including some ancestors from the Azores), from left to right, are the following colorful characters: Bill Berggman, 69 years old (Coast Guard and iron worker); Robert "Buzz" Myers, 69 years old, (construction and car wash); Gene Bettencourt, 72 years old, born in Half Moon Bay (dairy); Bill Avila, 76 years old, born in Half Moon Bay (cattle ranching and construction); and Ray Martini, 84 years old, born in Moss Beach (plumbing contractor). (Courtesy author.)

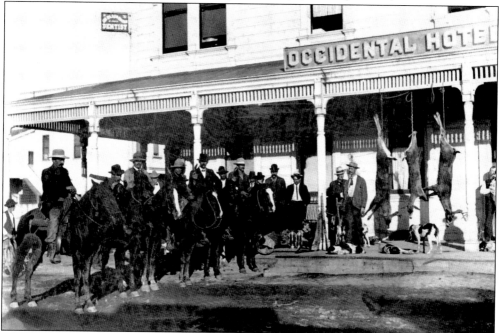

In 1902, horsemen are returning to the Occidental Hotel in Half Moon Bay from a successful hunt. (Courtesy A. Baccari.)

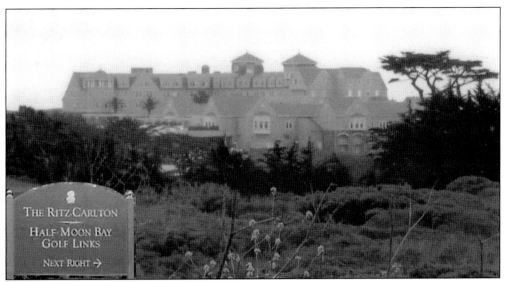

Built in 2001 on the ocean bluffs south of Half Moon Bay, the Ritz-Carlton is a far cry from the early roadhouses that have dotted the San Mateo coast since the 1800s. (Courtesy author.)

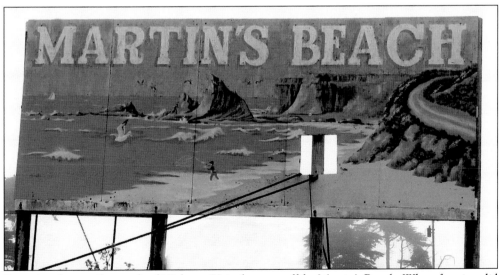

Six point three miles south of Highway 92 is the turn off for Martin's Beach. When farming did not prove profitable enough, the Deeney family bought Martin's Beach in 1910. The Deeney family leases the property to a few families who live there year round. There are also about 45 units for short-term rental. No dogs are allowed to bother Winslow the cat. (Courtesy author.)

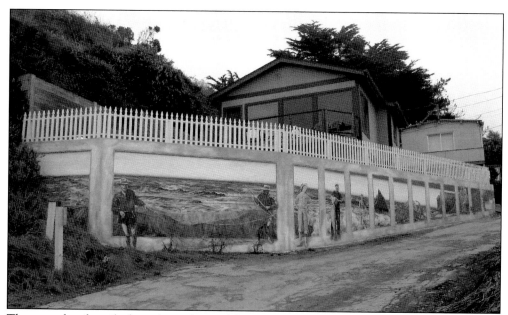

Three-tenths of a mile drive down the road from the Deeney's sign is the beach. In 1910, it cost 50¢ for a car with its passengers to enjoy the beach for the day; in 2005, the price is $10 a day. It is still worth it for guests to enjoy a beautiful secluded rustic resort. In 2004, this mural was painted by Christopher White on a retaining wall at Martin's Beach. (Courtesy author.)

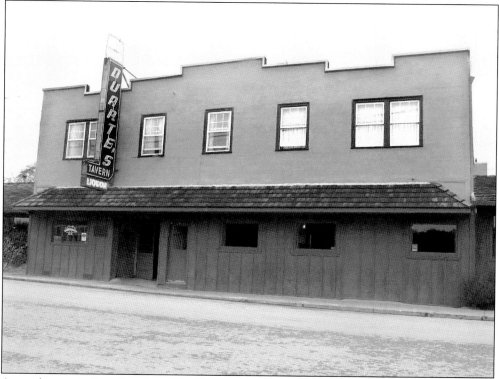

A popular stop in Pescadero since 1894, Duarte's is still famous for its artichoke soup and homemade pies. (Courtesy author.)

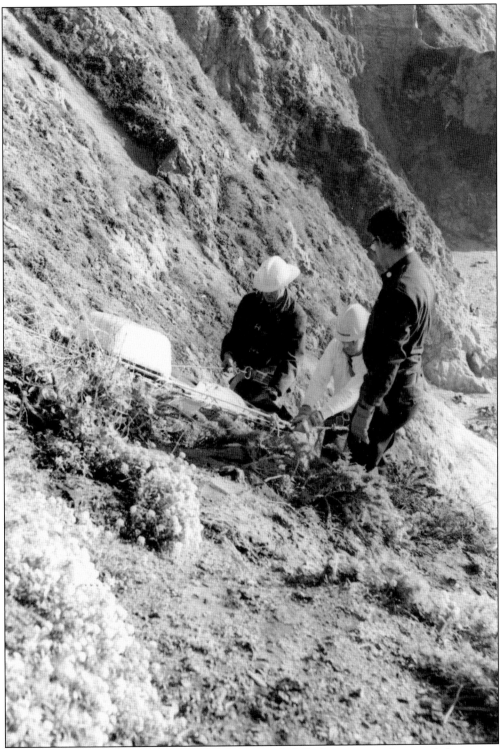

Despite all the warning signs about hiking on coastal cliffs, firemen are often needed to rescue unwary visitors, such as this one on a Devil's Slide cliff. (Courtesy J. Hillyer.)

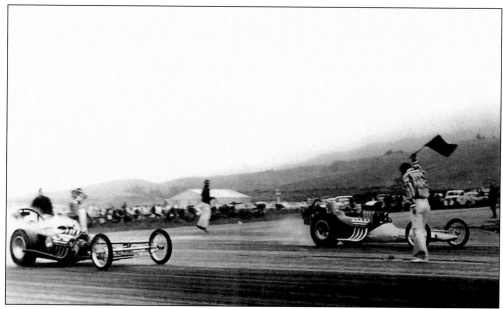

After the Second World War, the Half Moon Bay airport was converted for civilian use. In addition to use as an airport, the facilities have been home to other activities. Beginning in June 1957, dragster racing broke the coastal silence with a mighty roar. (Courtesy M. Andermahr.)

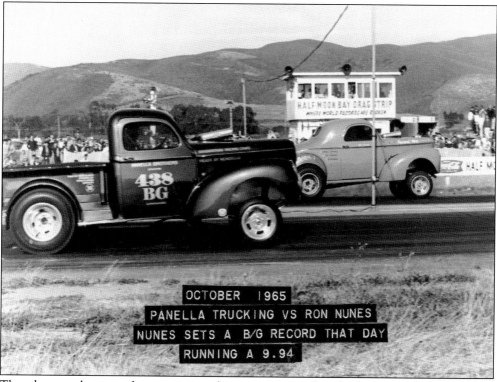

OCTOBER 1965
PANELLA TRUCKING VS RON NUNES
NUNES SETS A B/G RECORD THAT DAY
RUNNING A 9.94

Though a popular event for many years, the construction of nearby houses spelled the end for dragsters at the airport. (Courtesy M. Andermahr.)

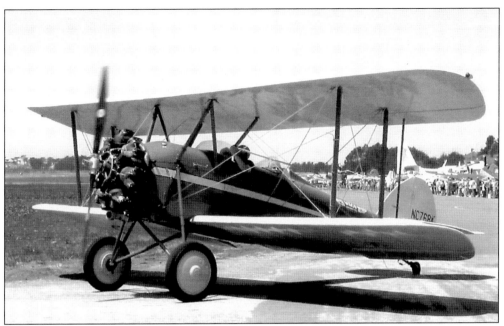

Now there is roller blade hockey on the tarmac, the airport cafe Zero Two Zero serves breakfast and lunch, and once a year local residents host the Dream Machines. Held the last Sunday in April, Dream Machines is a show of old farm machines, cars, and airplanes. Profits from the event provide financial support for senior citizens on the coast. Flying in an antique airplane is one of many thrills at Dream Machines. (Courtesy author.)

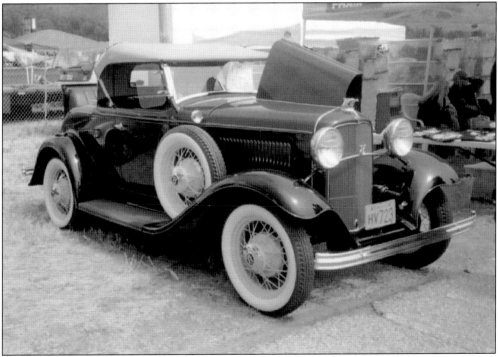

A 1932 Ford Coupe is on display at the Dream Machines show. (Courtesy N. Schoch.)

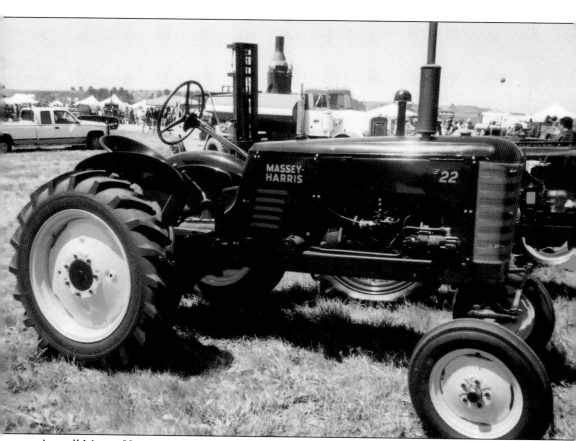

A small Massey-Harris tractor is on display at Dream Machines. (Courtesy author.)

Five

DEFENSES

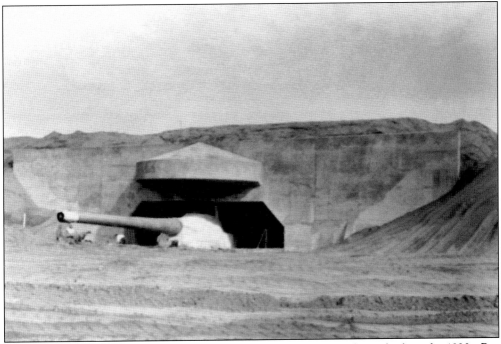

Four 16-inch guns were made for the USS *Saratoga* cruiser that was being built in the 1920s. But the Washington Naval Conference of 1922 resulted in an international treaty, stopping the cruiser's construction. The *Saratoga*, instead, was converted into an aircraft carrier. The 16-inch guns were transported to the West Coast in 1936, where two were mounted in the Marin headlands north of the Golden Gate and two mounted at Fort Funston. Each gun had a range of 26 miles. Thick reinforced concrete structures were built around the guns.

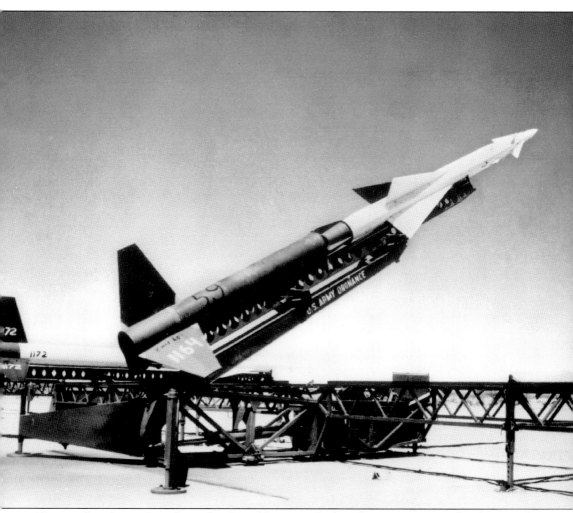

New warfare threats brought on by the cold war resulted in the construction of underground bunkers to hold Nike missiles at Fort Funston. Known by the military as the SF 59 Launch Site, Nike missiles were the primary operational medium-to-high altitude air defense weapon protecting the West Coast.

Though still known today as Fort Funston, it is no longer a military fort. Almost all the buildings from its military days were removed. The fort is now part of the Golden Gate National Recreation Area (GNRA), where hang gliders take off from the cliffs, cars are parked on the capped Nike bunkers, and hikers with their dogs wander over the sand dunes and through the concrete 16-inch gun batteries. (Courtesy author.)

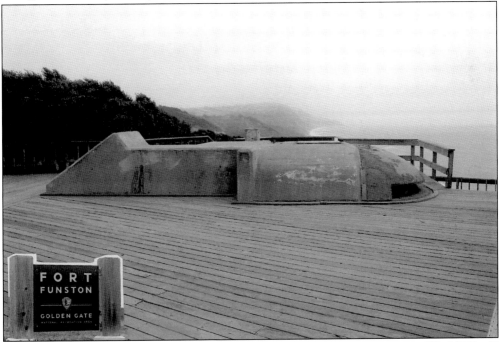

An observation deck built on the edge of a cliff at Fort Funston encompasses World War II observation bunkers. (Courtesy author.)

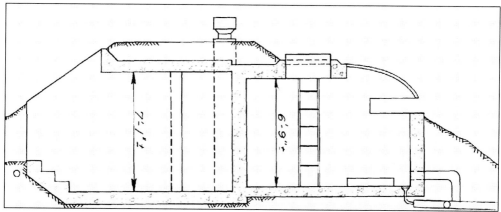

Near the old Ocean Shore Railroad bed at Mussel Rock in Pacifica, an almost four-acre site contained bunkers for observation. Often prefabricated and lowered into a hole, the bunkers along the coast were similar in construction and size: reinforced concrete with a manhole at the top for an entrance, a steel visor, and limited amenities for observers. So well made, many of them survive 60 years after they were constructed. (National Park Service.)

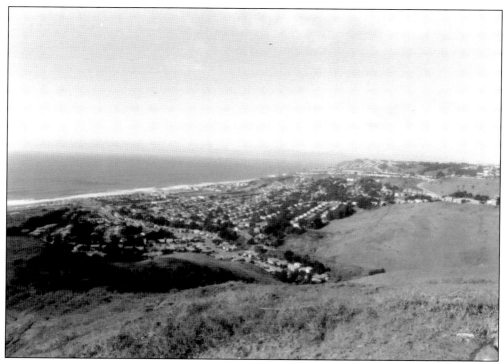

A few miles south of Mussel Rock, overlooking local towns 500 feet below, concrete bunkers were built at Milagra Ridge. Armed with two 50 caliber 6-inch guns, the fortification blended into the hillside. (Courtesy author.)

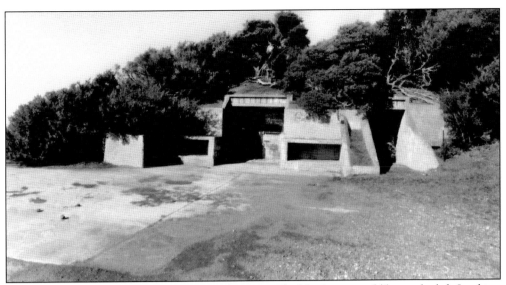

This is a view of the south end of these fortifications. The No. 2 gun would be on the left. Looking at the following construction drawing of this fortification, it is amazing what cannot be seen behind the welded shut doors. (Courtesy author.)

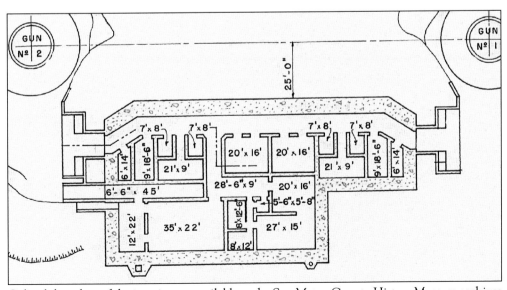

Color slides taken of the interior are available at the San Mateo County History Museum archives in Redwood City. (National Park Service.)

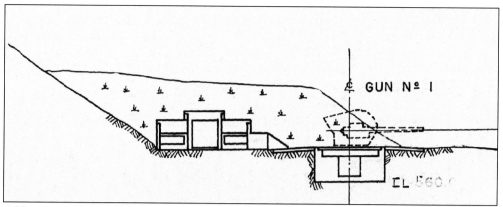

A blueprint side view of the number one gun at Milagra Ridge is seen here. (National Park Service.)

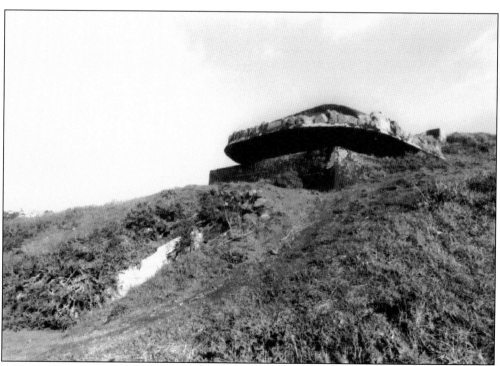

Known as fire control stations for guns, observation bunkers were also built at Milagra Ridge. (Courtesy author.)

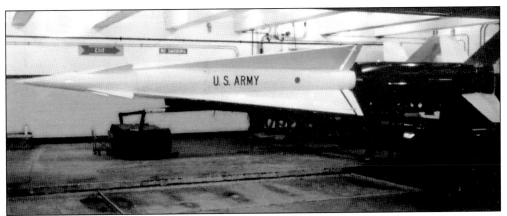

Before the Second World War ended, 16-inch guns were being planned for Milagra Ridge. Later when the cold war began, underground Nike bunkers were built there. These Nike Hercules missiles were each 42 feet long. (Courtesy author.)

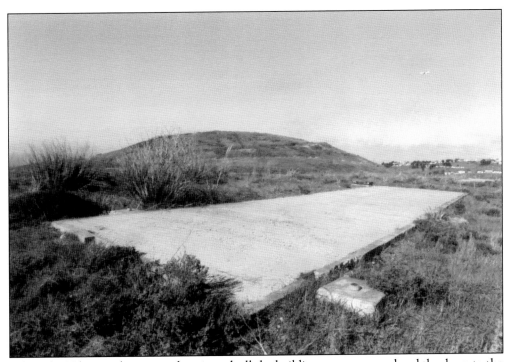

When the Nike missile site was deactivated, all the buildings were removed and the doors to the underground bunkers were capped with concrete. One has to look hard to find any traces of the Milagra Military Reservation other than these concrete slabs. (Courtesy author.)

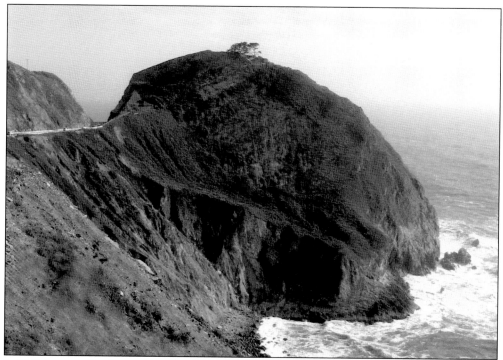

In 1941, between Pacifica and Farallone City, beside the coast highway completed in 1937 connecting the two communities, the Devil's Slide Military Reservation was built. It was comprised of several fire control stations and observation bunkers. Two of these stations and a steel observation tower were constructed on top of an imposing rock formation. Observers had to climb 190 wooden stairs on the side of a cliff to access the wind-swept heights. Three men manned each bunker. They operated range finding telescopes and SCR-296 surface radar systems. (Courtesy author.)

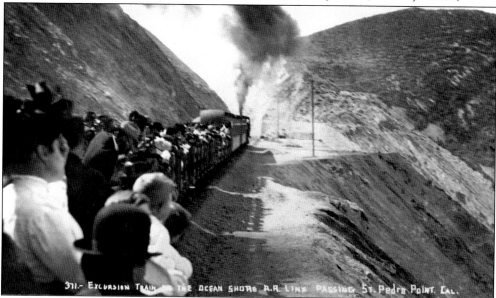

371.- EXCURSION TRAIN ON THE OCEAN SHORE R.R. LINE PASSING ST. PEDRO POINT. CAL.

In 1909, this Ocean Shore Railroad train is headed southbound. In the background are the rock formations where the Devil's Slide bunkers were later built upon. (Courtesy A. Baccari.)

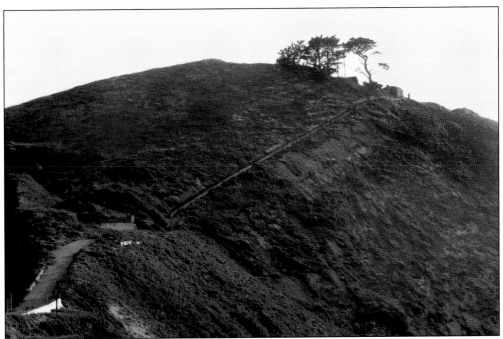

Today the stairs and bunkers are still in place. A concrete ramp on the left leads to one bunker that contained a power station for the bunkers at the top. From the power station, stairs rise to the bunkers, trees, and steel tower. The original wooden stairs were replaced with ones made of concrete. The tower rusts next to a lonely tree at the top. The stairs, however, have no handrail and they do not look stable. In the late 1990s, the Sprint telephone company submitted a proposal to mount one of their antennas on top of the steel tower. (Courtesy author.)

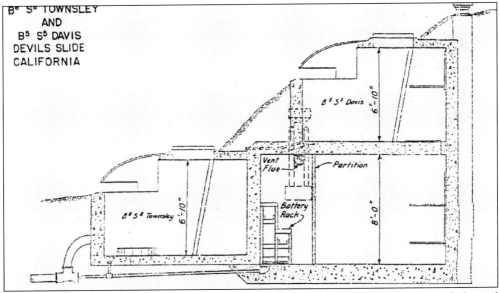

This side view shows the bunker at the top of the hill, with its entrance, a counterbalanced hatch, on top. The bunker contained two wire-frame, prison-type bunk beds, a switchboard, and a battery rack. There was no heat, no running water or a cooking stove. Food had to be brought in every day. (Courtesy author.)

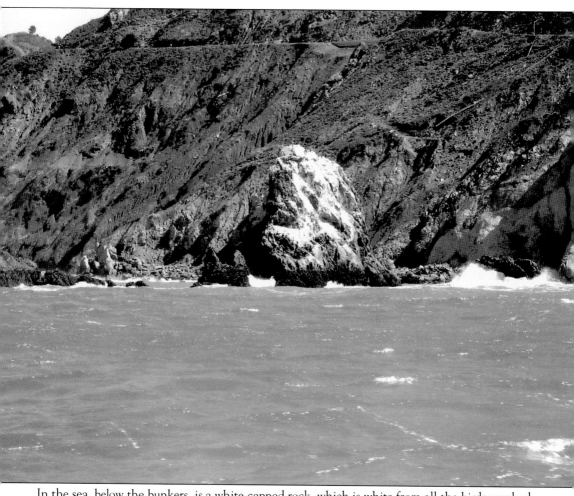

In the sea, below the bunkers, is a white-capped rock, which is white from all the birds perched on it. Today ornithologists sit at the base of the bunker ramp next to the highway and study the birds. Solar-powered cells and a camera were installed on the rock in 2005 in order to give visitors at the nearby Montara Lighthouse hostel a live feed of bird antics. (Courtesy author.)

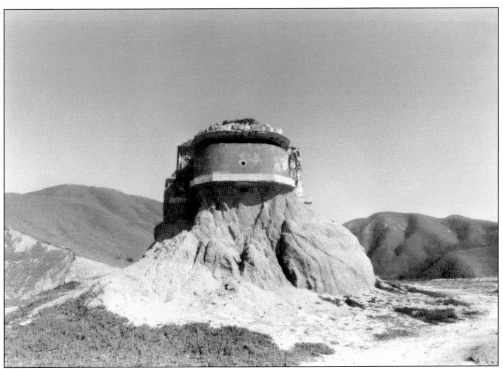

When originally constructed, this bunker was embedded in a hill. In 1963, this bunker and the surrounding land was sold to Alfred Wiebe. Wiebe hoped to build a "Monaco West" on the site. The builder removed the hill around the bunker, but the lack of access to water and electricity doomed the project. (Courtesy author.)

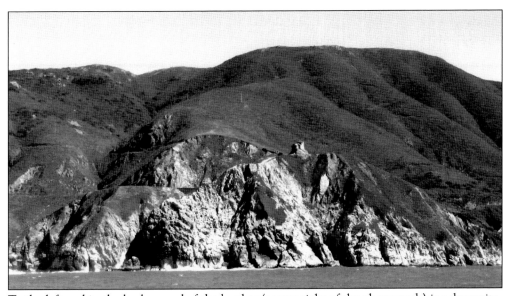

To the left and in the background of the bunker (center right of the photograph) is a dynamite-blasted cut for the coast highway. (Courtesy author.)

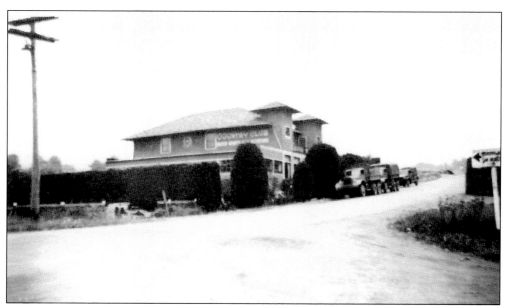

South of the Devil's Slide Military Reservation is the small coastal community of Montara. During the Second World War, Montara's first post office, built in 1907, was converted for use as U.S. Army officer quarters. The army rarely built any new quarters, preferring instead to use existing buildings. The army dubbed the facility "Country Club." (Courtesy J. Hillyer.)

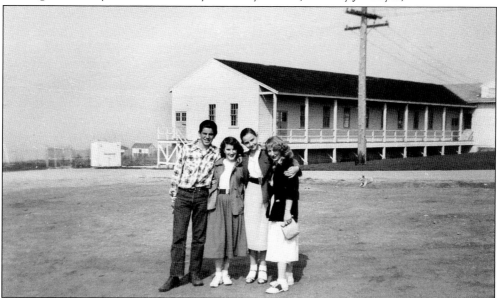

South of the Point Montara Lighthouse, the U.S. Navy built a gunnery school and a radio station. Today the old radio station houses the offices of the local water and sewer departments. During World War II, the sounds of automatic weapons reverberated throughout Montara during gunnery practice. Mary Potter, the widowed wife of Seaman Potter, who had been a gunnery instructor at the school during the war, said that sometimes the trainees would get bored with practice and take their boredom out by trying to hit the planes pulling their targets. Later radio-controlled miniature planes were used for target practice. Here Rob Bettencourt poses with three friends. (Courtesy Ida Bettencourt.)

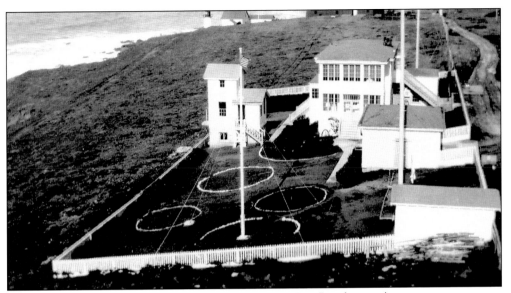

Shown here is the Moss Beach radio station. (Courtesy J. P. Ruschmeyer.)

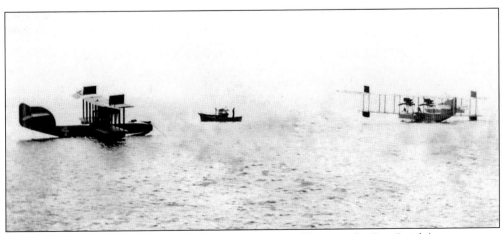

These World War I seaplanes landed near Patroni's pier. (Courtesy R. Guy Smith.)

In 1942, a naval airfield was built in Half Moon Bay for air reconnaissance and target practice for the gunnery school. PBY aircraft patrolled the coastline and trainers pulled targets. After the war, the Half Moon Bay Airport was a standby airport for San Francisco International Airport. People often say that when San Francisco is fogged in, Half Moon Bay is clear and usable. (Courtesy author.)

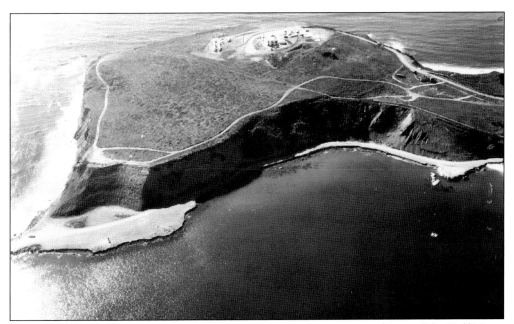

On a strategic spit of almost barren land jutting out into the ocean, southwest of the Half Moon Bay airport, is the only still active military installation on the San Mateo coast. Called the Pillar Point U.S. Air Force Station today, it sits 175 feet above the sea. This 55-acre parcel is relatively flat and covered with scrub brush, ice plant, and a small grove of Monterey Cypress trees. Steep cliffs surround the point. (Courtesy D. Inch.)

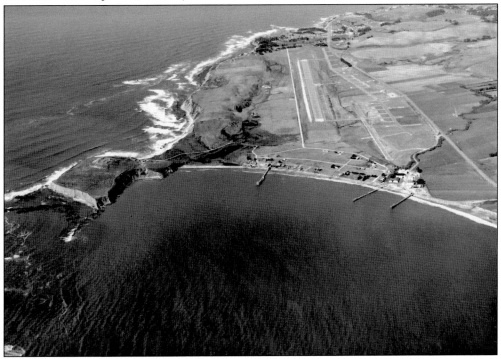

During World War II, the U.S. Army built a series of bunkers as an observation station to watch for enemy ships and planes. (Courtesy D. Inch.)

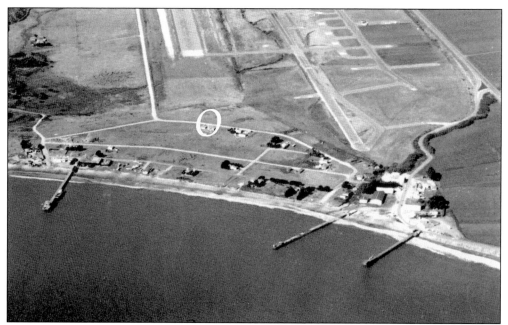

A 1958 photograph shows Pillar Point, the Half Moon Bay Airport, and Princeton Harbor before the breakwater was constructed. Of the three piers shown in this photograph, only the one on the left is still standing. Known as the Green Pier, it is in decrepit condition and is no longer used. Also, parallel and on the west side of the runway is the Seal Cove earthquake fault. It is difficult to see, but lining up with the center and south end of the runway is Ed and Laura Souter's house that they built in 1938. Ed used to own a business in San Carlos, which he commuted to by flying his own airplane. Before the airport was built, Ed flew his airplane from "over the hill" to a cow pasture in Half Moon Bay and then drove home in his car. (Courtesy J. Hillyer.)

After World War II, Ed flew into Half Moon Bay Airport, using the tall chimney on his house to guide him for takeoffs and landings. (Courtesy author.)

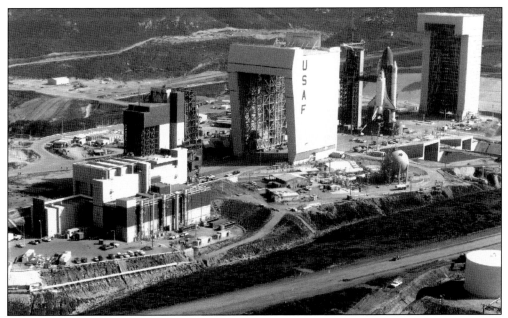

After World War II, the observation station at Pillar Point was deactivated. In 1964, the U.S. Air Force took command of this operation and ITT Federal Services Corporation managed the site for 40 years. Their mission was to support missile launches from Vandenberg Air Force Base. Today the Endye Corporation manages the site for the 30th Space Wing of the Air Force Space Command. The site's primary functions are to provide real-time range safety and for post-flight evaluation of ballistic missiles fired from Vandenberg Air Force Base. (Courtesy D. Inch.)

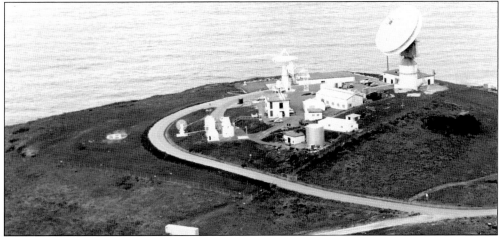

On February 3, 1975, the New World Liberation Front bombed the USAF Pillar Point installation—probably the only time the San Mateo coast was ever attacked. By stealth, during a night of violent thunderstorms, members of this radical group entered an opening in the perimeter fence and placed a two-inch diameter pipe bomb, about eight and a half inches long, underneath a diesel fuel tank. According the station manager Dennis Inch, the apparent intent was to ignite the fuel and cause a spectacular explosion. Instead the bomb blew a hole in the bottom of the tank causing about 400 gallons of fuel to drain out onto the ground. After the bombing, the Air Force upgraded the security of the site with more lighting, fencing, alarm systems, and other security measures.

On the west side of Pillar Point is an area of water called Mavericks. The adjoining beach area includes tide pools for exploration. Low tides expose the pools here and also at Fitzgerald Marine Reserve in Moss Beach, near the distillery. During the winter, sometimes there are low tides of minus two and a half, which is an ideal time to explore these pools. (Courtesy author.)

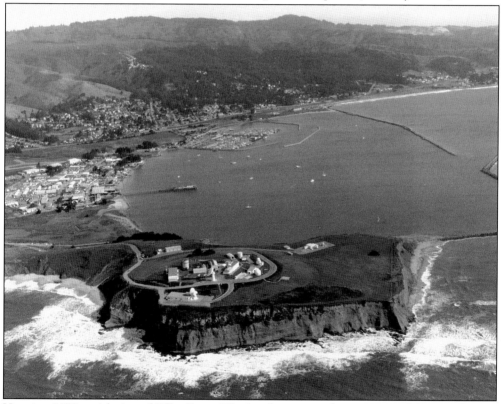

Here is a 1999 aerial view of Pillar Point. The breakwater can be seen east of the installation. This is the only protected harbor between San Francisco and Santa Cruz. Mavericks, in the left foreground, is a world renowned surfing location. (Courtesy D. Inch.)

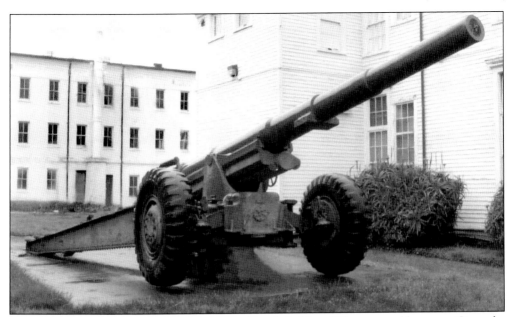

Additional coastal defenses during World War II included four 155-mm portable guns at Granada. The U.S. Army's 56th Coast Artillery towed these guns in place. Today one of these guns sits next to the old hospital at the decommissioned Presidio Army Base in San Francisco. (Courtesy author.)

On the southern outskirts of Half Moon Bay, on the west side Highway 1, is a 100-year-old building called Cameron's. Before the Second World War, it was known as the Wave Crest Inn. The U.S. Army took over the inn to use it for the first horse marine headquarters. Foot and horse patrols on local beaches were directed from here. (Courtesy author.)

BIBLIOGRAPHY

Chin, Brian B. *Artillery at the Golden Gate, the Harbor Defenses of San Francisco in World War II*. Missoula, MT: Pictorial Histories Publishing Company, Inc., 1999.

Brown, Dr. Allan K. *Place Names of San Mateo County*. San Mateo, CA: San Mateo County History Association, 1975.

Geology Guidebook of the San Francisco Bay Counties. Bulletin 154. Division of Mines. San Francisco, 1951.

Gillespie, Bunny. *The Great Daly City Historical Trivia Book*. Daly City, CA: Gillespie & Company, 1986.

Holman & Associates. *Site Submittal Package for Devil's Slide—Highway 1 Antenna Installation County of San Mateo—Midcoast Area*. San Francisco, CA: Randall Dean, 1999.

Konigsmark, Ted. *Geologic Trips, San Francisco and the Bay Area*. Gualal, CA: Geo Press, 1998.

Lewis, Emanuel Raymond. *Seacoast Fortifications of the United States, An Introductory History*. Annapolis, MD: Naval Institute Press, 1970.

Manning, Kathleen and Crow, Jerry. *Half Moon Bay*. Charleston, SC: Arcadia Publishing, 2004.

Sloan, Doris. *Down to the Sea*. Department of Earth and Planetary Science, UC Berkeley.

Smookler, Michael. *Montara—A Pictorial History*. Montara. California, 2005.

Reinstedt, Randall A. *Shipwrecks and Sea Monsters of California's Central Coast*. Carmel, CA: Ghost Town Publications, 1975.

Wagner, Jack R. *The Last Whistle (Ocean Shore Railroad)*. Berkeley, CA: Howell-North Books, 1974.

West, Don and Cotchett, Joseph W. *The Coast Time Forgot, The Complete Tour Guide to the San Mateo Coast*. Moss Beach, CA: Thornton House, 2002.